2003

ELIZABETH PEYTON

ELIZABETH PEYTON

Herausgegeben von
Edited by

Zdenek Felix

Hatje Cantz Verlag

Leihgeber/*Lenders*

Renato Alpegiani Collection
Eheleute Altfeld-Gnotke
Collection Boros
Collection Gavin Brown
Gavin Brown's enterprise
Collection Monica de Cardenas, Milano
Sadie Coles HQ, London
Collection Mandy & Cliff Einstein, Los Angeles
EVN Collection
Ole Faarup Collection, Copenhagen
Collection Linda Farris & John Kucher, Seattle
Fascher Collection
Les Firestein
Laura Steinberg & Bernardo Nadal Ginard
André & Joceline Gordts-Vanthournout, Belgien
Mimi & Peter Haas
Emanuel-Hoffmann-Stiftung, Depositum im
 Museum für Gegenwartskunst, Basel
Susan & Michael Hort
Collection Tony Just & Elizabeth Peyton
Collection Lichtenberg
Collection Lobeck
Susan & Lewis Manilow
Collection Byron R. Meyer, San Francisco
Collection Nina & Frank Moore
MORA Foundation,
 Mark Fletcher/Art Management
Neugerriemschneider, Berlin
Collection Olbricht
Collection Patricia & Morris Orden, New York
Martin Perrin
Elizabeth Peyton
Musée national d'art moderne,
 Centre Georges Pompidou, Paris
Collection Nancy & Joel Portnoy
Collection Rob Praitt
Mima & César Reyes, San Juan, Puerto Rico
Collection Andrea Rosen
Lorenzo Sassoli di Bianchi Collection, Bologna
Collection Tatsumi Sato
The Giovanni Solari Collection

The Speyer Family Collection, New York
Collection Karen & Andy Stillpass
Collection Nancy Stillpass, New York
Collection Zoe Stillpass
Collection David Teiger
Wolfgang Tillmans
Laura Steinberg Tisch & Stafford Broumand
Collection Mr. & Mrs. Jeffrey R. Winter
Kunstmuseum Wolfsburg
David & Monica Zwirner, New York

sowie Leihgeber, die nicht genannt sein wollen
and lenders who do not wish to be mentioned

Inhalt/*Content*

In Peyton's World

By Zdenek Felix

The American painter Elizabeth Peyton, equally recognized for her drawings, was born in 1965 in Danbury, Connecticut. From 1984–87 she studied at the School of Visual Arts in New York, where she still lives and works. Her first solo exhibition was presented in 1987 by Althea Viafore in New York, followed in 1993 by the notable presentation of historical portraits in Room No. 828 at the legendary Chelsea Hotel and by exhibitions in 1995 at Gavin Brown's enterprise in New York as well as at Burkhard Riemschneider's in Cologne, initiating a longstanding cooperation with the two galleries. More extensively, the artist's pictures and drawings have been shown since 1997 at the Saint Louis Art Museum, the Seattle Art Museum, the Museum für Gegenwartskunst in Basle and the Kunstmuseum Wolfsburg.

When first viewing the pictures of Elizabeth Peyton five years ago, I felt immediately enchanted by the peculiar aura of these small, vibrantly colorful works, a magical moment in which countless ideas and associations come together, converging as within a focal point. But also my later encounters with the strange world of these pictures have always kept their same intensity for me. Furthermore, Peyton's works appear to be exemplary for newer tendencies in art toward the ›realistic‹ and the ›portrait‹, categories which are gaining increasing significance after the long period of rejection of figurative painting. I consider it very fortunate that an exhibition containing nearly 120 of Elizabeth Peyton's works can now be presented in Hamburg, particularly since her works are scattered over a number of private collections in the United States and Europe, and due to their fragility, are highly complicated to adequately handle. The afternoon I was able to spend together with Elizabeth Peyton at Gavin Brown's gallery, poring over the numerous files of slides, will remain unforgettable to me. We made a preliminary selection which, later refined by the artist, now serves as the basis of this exhibition. We concluded the session in the dimly lit bar of the gallery with a glass of American beer.

Peyton's principal subject is the portrait. In her generally small-format oil paintings, drawings and watercolors, people appear who appeal to her or have impressed her as historical figures. On her list of models one finds, on the one hand, friends and acquaintances like the artists Craig Wadlin, Tony Just or Piotr Uklanski, and, on the other, celebrities, both old and new, who spark the imagination of many: Napoleon Bonaparte, Marie Antoinette and Ludwig II of Bavaria, for example. Members of the British royalty, such as Lady Di and her sons, made legendary through the media, or characters like Lord Alfred Douglas, Oscar Wilde's companion known under the nickname Bosie. The repertoire also includes artists Peyton has high esteem for, like David Hockney and Andy Warhol, film stars such as Leonardo diCaprio, as well as pop musicians, for instance the »Nirvana« lead singer Kurt Cobain, who spectacularly committed suicide a few years ago, punk rocker Sid Vicious, or the glamorous star of the British pop band »Pulp«, Jarvis Cocker. Essential in choosing a subject for portrayal is the possibility of identifying with the given person's charisma, his or her influence and destiny, as well as with the person's ability to create his or her own world. »I think about how influential some people are in others' lives. So it doesn't matter who they are or how famous they are but rather how beautiful is the way they live their lives and how inspiring they are for others. And I find this in people I see frequently as much as in people I never met,« as the artist stated in 1996 in an interview with Francesco Bonami.[1]

›Public‹, widely circulated images taken from books, magazines, record covers, or music video stills serve Elizabeth Peyton as source material as well as ›private‹ photographs taken by herself. Characteris-

In Peytons Welt

Von Zdenek Felix

Die amerikanische Malerin und Zeichnerin Elizabeth Peyton wurde 1965 in Danbury, Connecticut, geboren. In den Jahren 1984–87 studierte sie an der School of Visual Arts in New York, wo sie seitdem lebt und arbeitet. Ihre erste Einzelausstellung fand 1987 bei Althea Viafore in New York statt. 1993 folgte die denkwürdige Schau von historischen Porträts im Zimmer Nr. 828 des legendären Chelsea Hotel und 1995 die Ausstellungen bei Gavin Brown's enterprise in New York wie auch bei Burkhard Riemschneider in Köln, die den Anfang einer langjährigen Zusammenarbeit mit den beiden Galerien einleiteten. Größere Übersichten von Bildern und Zeichnungen der Amerikanerin wurden seit 1997 im Saint Louis Art Museum, im Seattle Art Museum, im Museum für Gegenwartskunst in Basel und im Kunstmuseum Wolfsburg gezeigt.

Als ich vor fünf Jahren zum ersten Mal die Bilder von Elizabeth Peyton sah, fühlte ich mich augenblicklich von der merkwürdigen Ausstrahlung dieser kleinen, farbig funkelnden Werke angezogen, ein magischer Moment, in dem sich unzählige Vorstellungen und Assoziationen bündeln und wie in einem Brennpunkt zusammenlaufen. Aber auch die späteren Begegnungen mit der seltsamen Welt dieser Bilder haben für mich an Intensität nichts eingebüßt. Peytons Arbeiten erscheinen zudem exemplarisch für die Tendenz der neueren Kunst zur ›Realistik‹ und zum ›Porträt‹, Kategorien, die nach langjähriger Abkehr von der figürlichen Malerei an Bedeutung gewinnen. Dass jetzt in Hamburg eine beinahe 120 Arbeiten umfassende Ausstellung von Elizabeth Peyton zustande kommt, halte ich für einen Glücksfall, zumal ihre Werke in zahlreichen Privatsammlungen in Amerika und Europa verstreut und wegen ihrer Fragilität äußerst diffizil zu handhaben sind. Unvergeßlich bleibt für mich der Nachmittag, den ich mit Elizabeth Peyton in der Galerie von Gavin Brown in New York über den zahlreichen Aktenordnern mit Diapositiven verbringen konnte. Wir haben eine Vorauswahl getroffen, die, von der Künstlerin später verfeinert, Grundlage der jetzigen Ausstellung ist. In der schummrigen Bar der Galerie gab es zum Abschluß ein amerikanisches Bier.

Peytons Hauptthema ist das Porträt. In ihren meist kleinformatigen Ölbildern, Zeichnungen und Aquarellen tauchen Menschen auf, von denen sie sich angesprochen fühlt oder die sie als historische Figuren beeindruckt haben. Auf der Liste ihrer Modelle finden sich einerseits Freunde und Bekannte wie die Künstler Craig Wadlin, Tony Just oder Piotr Uklanski und andererseits Berühmtheiten, alte und neue, die die Phantasie vieler Menschen beflügeln: Napoleon Bonaparte, Marie Antoinette und Ludwig II. von Bayern beispielsweise, Mitglieder des britischen Königshauses, wie die von den Medien zur Legende erhobene Lady Di und ihre Söhne oder Gestalten wie Lord Alfred Douglas, der unter dem Kosenamen Bosie bekannte Freund von Oscar Wilde. Zum Repertoire zählen ebenfalls Peytons künstlerische Vorbilder wie David Hockney und Andy Warhol, Filmstars wie Leonardo diCaprio, aber auch Pop-Musiker, etwa der »Nirvana«-Sänger Kurt Cobain, der vor einigen Jahren spektakulär Selbstmord verübte, der Punk-Rocker Sid Vicious oder der glamouröse Star der britischen Pop-Band »Pulp«, Jarvis Cocker. Wesentlich für die Wahl der porträtierten Person ist die Möglichkeit der Identifikation mit ihrer Ausstrahlung, Wirkung und ihrem Schicksal, wie auch mit deren Fähigkeit, eine eigene Welt zu schaffen. »Ich denke darüber nach, wie bestimmte Leute das Leben anderer beeinflußt haben. Es ist nicht entscheidend, wer sie sind oder wie berühmt, eher wie schön der Weg ist, den sie in ihrem Leben beschritten haben und wie inspirierend sie für die anderen waren. Und ich finde

tically, there is no difference in ›Peyton's world‹ between the two realms. Historical figures and living people appear as ephemeral beings with pale eyes and scarlet lips and seem androgynous, rather than belonging to a certain gender. They exist in a Proustian ›timelessness‹ in which the past and the present overlap »without distinguishing between actually and fictitiously experienced places.«[2] What links the pictures is a tangible intimacy reflected also in the titles of the works, which usually only reveal the first names of the models. We are witnesses of an individual quest for fragile beauty and eternal youth, features atmospherically reminiscent of fin-de-siècle art after 1890. At the same time, the pictures are eminently of today since they articulate our yearning for beauty and humanity without being frivolous or nostalgic. »[...] the utopia of pure aestheticism,« the Swiss art historian Philip Ursprung noted concerning the work of Elizabeth Peyton, »still lingers on in the fairy-tale aura that surrounds contemporary stars whose ›private lives‹ are so interesting because they are a domain where fantasy can run free, and which neither the stars nor the public have entirely at their command. In Peyton's hands, painting takes on comparable characteristics, that is, it is a domain which may not entirely be controlled. She fluctuates between utopian claims to universal relevance and her consciousness of the limitations of an artform past its prime – and it is this very dualism that generates the sheer excitement of her art.«[3]

My sincere gratitude goes to the artist for her engagement during the preparations for the exhibition and to Gavin Brown in New York as well as to Burkhard Riemschneider and Tim Neuger in Berlin for their aid and counsel. Without the willingness of numerous private collectors to part with their works during the exhibition the project would never have been made possible. I particularly wish to thank the sponsor, British American Tobacco, for generously supporting our endeavor.

1 *Francesco Bonami, »Elizabeth Peyton, We've Been Looking at Images for so Long That We've Forgotten Who We Are« in: Flash Art International, vol. XXIX. No. 187, March–April, 1996, pp. 84 ff.*
2 *Raimar Stange was the first to point out the correspondences between the aesthetics of Elizabeth Peyton and the literary method of Marcel Proust, in: Artist Kunstmagazin, vol. 37, pp. 46 ff.*
3 *Philip Ursprung, »Lob der Hand. Zu Elizabeth Peytons Malerei« (translation: Fiona Elliott), in: Parkett, vol. 53, 1998, pp. 80 ff.*

das bei Leuten, die ich oft sehe, wie auch bei jenen, denen ich nie begegnete«, sagte die Künstlerin 1996 in einem Interview mit Francesco Bonami.[1]

Als Vorlagen dienen Elizabeth Peyton sowohl ›öffentliche‹, weit verbreitete Bilder, die sie Büchern, Magazinen, Plattencovern oder Stills von Musikvideos entnimmt, als auch eigene, von ihr selbst aufgenommene, ›private‹ Fotos. Bezeichnenderweise gibt es in ›Peytons Welt‹ keinen Unterschied zwischen den beiden Bereichen. Historische Gestalten und lebende Menschen erscheinen als ephebenhafte Wesen mit hellen Augen und scharlachroten Lippen, eher androgyn als einem Geschlecht angehörig. Sie leben in einer Proustschen ›Zeitlosigkeit‹, in der sich die Vergangenheit und Gegenwart überlagern, »ohne zwischen tatsächlich und fiktiv erlebten Orten zu unterscheiden.«[2] Verbindend für die Bilder ist eine spürbare Intimität, welche sich auch in den Werktiteln widerspiegelt, die meist nur die Vornamen der Modelle preisgeben. Wir sind Zeugen einer individuellen Suche nach zerbrechlicher Schönheit und immerwährender Jugendhaftigkeit, Eigenschaften, die atmosphärisch an die Kunst des Fin de Siècle nach 1890 erinnern. Dabei sind die Bilder eminent gegenwärtig, da sie von unserer Sehnsucht nach Schönheit und Menschlichkeit erzählen, ohne dabei leichtfertig utopisch oder nostalgisch zu sein. »Die Utopie völliger Ästhetisierung«, schrieb der Schweizer Kunsthistoriker Philip Ursprung zum Werk von Elizabeth Peyton, »lebt heute allenfalls weiter in der märchenhaften Aura der Stars. Deren ›Privatsphäre‹ ist deswegen so interessant, weil sie ein Ort bleibt, in dem die Phantasie sich bewegen darf und über den weder Stars noch die Öffentlichkeit verfügen können. In Peytons Hand wird die Malerei zu etwas Vergleichbarem, also zu einem Ort, über den nicht restlos verfügt werden kann. Sie pendelt zwischen dem utopischen Anspruch auf universelle Gültigkeit und dem Wissen um die Grenzen einer alternden Kunst. Aus diesem Dualismus erwächst ihre Spannung.«[3]

Mein herzlicher Dank gilt der Künstlerin für ihr Engagement bei den Vorbereitungen der Ausstellung sowie Gavin Brown in New York und Burkhard Riemschneider und Tim Neuger in Berlin für deren Hilfe und Rat. Ohne die Bereitschaft zahlreicher Leihgeber, sich von ihren Werken zu trennen, wäre das Projekt undenkbar. Ganz besonders möchte ich dem Sponsor, British American Tobacco, für die großzügige Unterstützung unseres Vorhabens danken.

1 Francesco Bonami, Elisabeth Peyton, We've Been Looking at Images for so Long That We've Forgotten Who We Are. Flash Art International, Vol. XXIX, Nr. 187, März–April 1996, S. 84 ff.
2 Als erster hat Raimar Stange auf die Zusammenhänge zwischen der Ästhetik von Elizabeth Peyton und der literarischen Methode von Marcel Proust hingewiesen, in: Artist Kunstmagazin, Heft 37, 4/1998, S. 46 ff.
3 Philip Ursprung, Lob der Hand. Zu Elizabeth Peytons Malerei, Parkett, Nr. 53, 1998, S. 80 ff.

A revolt from Reason

by Ronald Jones

There are in our existence spots of time,
That with distinct pre-eminence retain
A renovating virtue, whence – depressed
By false opinion and contentious thought,
Or aught of heavier or more deadly weight,
In trivial occupations, and the round
Of ordinary intercourse – our minds
Are nourished and invisibly repaired;
A virtue, by which pleasure is enhanced …

Imagination and Taste, How Impaired and Restored
From »The Prelude«, 1850

William Wordsworth

It was for the Salon of 1781 that Ménageot hung his painting of Leonardo da Vinci dying in the arms of Francis I. For Ménageot it was pure veneration that carried him off romanticizing the history of art, representing scenes from the biographies of celebrated artists. For the whole of his career, he was dedicated to this tradition that had found its beginnings in the late eighteenth century. And from this font, other

Francois-Guillaume Ménageot
»The death of Leonardo da Vinci«, 1781

like-minded painters would cascade revering artists of stature, and those who left behind an impression deep with resonance.

In every case, it was a matter of adoration, and in this respect one could not help but think back to Ménageot or say Bergeret, who memorialized the death of Raphael in 1806, when accounting for the work of Elizabeth Peyton. To think of her portraiture as her opportunity to say more about this time-honored custom is all too apparent. These sorts of associations, two and three deep, readily come to mind would you think about her work even for a moment. Leafing through these comparisons – between this tradition of portraiture and Elizabeth's art – it is Jean-Auguste-Dominique Ingres that surfaces amongst the rest. My intention is not to claim that Elizabeth is a painter of Ingres' rank (that's all apples and oranges), but rather that she is gripped in veneration for her subjects, as was Ingres. For Ingres it was Raphael – for Elizabeth, Kurt Cobain. For the moment, set aside the ready and blunt-minded instrument that would cleave high from low, Raphael from Cobain, to hear this: separated by nearly two hundred years, each artist is swallowed up in an unbridled reverie for a personality of vast creative influence.

It would not be overstepping the truth to say that Raphael obsessed Ingres. He reinterpreted his pictures; he was a student of his life. In 1812 Ingres planned a series of paintings devoted to the life of Raphael, and carrying out his research studied Vasari and Comolli. In the end, the pictures he painted of Raphael happened to zero in on his relationships with women; naturally the 1814 canvas »Raphael and The Fornarina« comes to mind. Ingres had painted an earlier version of »The Fornarina« in 1813 but when that was lost, he made another in the very next year, and that picture now hangs in the Fogg Art

Aufstand gegen die Vernunft

Von Ronald Jones

In unserem Leben gibt es Augenblicke,
Die mit klarem Vorrang
Eine erneuernde Eigenschaft bewahren, wodurch – geschwächt
Durch falsche Überzeugung und umstrittenes Denken,
Oder etwas von schwererem oder tödlicherem Gewicht,
In belanglosen Beschäftigungen und dem Reigen
Gewöhnlichen Verkehrs – unser Geist
Genährt wird und auf unsichtbare Weise frisch gestärkt;
Eine Eigenschaft, durch die Genuss gesteigert wird…

Imagination und Geschmack, wie geschwächt und wieder hergestellt
(Aus: »The Prelude«, 1850)

William Wordsworth

Anlässlich des Salons im Jahr 1781 präsentierte Ménageot sein Gemälde von Leonardo da Vinci, der sterbend in den Armen von Franz I. liegt. Es war innige Verehrung, die Ménageot dazu bewog, die Kunstgeschichte zu romantisieren und Szenen aus den Biografien berühmter Künstler wiederzugeben. Während seines gesamten Schaffens blieb er dieser Tradition, die ihren Ursprung im späten 18. Jahrhundert hat, verhaftet. Und aus dieser Quelle sollten noch etliche Maler gleicher Gesinnung hervorsprudeln, die Künstlern von Format und nachhaltiger Resonanz ihre Reverenz erwiesen.

In allen Fällen ging es um tiefe Bewunderung, und man kann nicht umhin, sich an Ménageot oder auch Bergeret zu erinnern, der 1806 dem Tode Raffaels ein Denkmal setzte, will man Elizabeth Peytons Werk beschreiben. Ihre Porträts als Möglichkeit zu begreifen, dieser althergebrachten Sitte etwas Neues hinzuzufügen, liegt allzu nahe. Ganze Assoziationsketten dieser Art kommen einem sofort in den Sinn, wenn man ihre Arbeiten auch nur flüchtig betrachtet. Geht man im Geiste die Vergleiche durch – zwischen jener Tradition der Porträtmalerei und der Kunst Elizabeth Peytons – dann sticht in erster Linie Jean-August-Dominique Ingres aus der übrigen Menge heraus. Damit will ich keineswegs behaupten, dass Elizabeth Peyton eine Malerin von Ingres' Rang ist (das wäre so, als wolle man Äpfel mit Birnen vergleichen), sondern vielmehr, dass sie die Verehrung für ihre Sujets mit Ingres teilt. Bei Ingres richtete sich diese Verehrung auf Raffael, bei Peyton auf Kurt Cobain. Legen wir für einen Augenblick das jederzeit einsatzbereite und gedanklich stumpfe Instrument beiseite, das High und Low, Raffael und Cobain, sofort trennen würde, um Folgendes zu vernehmen: Durch fast zwei Jahrhunderte voneinander getrennt, sind beide Künstler jeweils verstrickt in eine ungezügelte Schwärmerei für eine Persönlichkeit von gewaltiger, schöpferischer Auswirkung.

Jean-Auguste-Dominique Ingres, »Raphael and The Fornarina«, 1814

Es ist nicht übertrieben zu sagen, dass Ingres von Raffael förmlich besessen war. Er interpretierte seine Gemälde neu; er studierte seine Biografie. 1812 plante Ingres eine Serie von Gemälden, die dem Leben von Raffael gewidmet sein sollten, und befasste sich im Zuge seiner Recherchen auch mit Vasari und Comolli. Am Ende rückten die Bilder, die er von Raffael malte, an seine Beziehungen zu Frauen

Museum at Harvard. I discovered it wandering the halls of the Fogg between my lectures, and while I had never seen it in the flesh, I had often thought about it where Elizabeth's art was concerned. In 1813, the year of his own marriage to Madeleine Chapelle, Ingres chose to paint Raphael's engagement to the niece of Cardinal Bibiena, and then followed that with the Fornarina picture. No one less than Robert Rosenblum has wondered if the timing was only coincidence, or autobiography.

It is relatively small, the Fornarina picture – roughly two feet wide and tall – quite intimate as a result. Fornarina, the daughter of a baker, had been the object of Raphael's adoration, a love affair Ingres knew by heart. Until modern scholarship re-attributed the 1516 canvas »La Fornarina« to Raphael's student Giulio Romano, it was widely believed that the picture belonged to Raphael. Certainly Ingres believed it to be a part of his oeuvre: it is the very picture on Raphael's easel in Ingres' 1814 painting of the artist and his lover. As Ingres depicts the scene, Raphael holds tight to Fornarina, but it is her picture that has cast a spell over the artist. He is caught between two truths (and also two loves) – art and reality. At the very moment they begin to dissolve into one another at their edges, the woman in his arms disappears into her idealized image. Elizabeth readily admits to the same dilemma. She told Francesco Bonami: »There is no separation for me between people I know through their music or photos and someone I know personally. The way I perceive them is very similar, in that there's no difference between the certain qualities I find inspiring in them.«

Elizabeth Peyton,
»Andy at the Factory«, 1997

Somewhere along the way, second-tier critics and many of her first-rate fans mistook the scent of Elizabeth's pictures for pure »teen spirit« transmogrified into art. When they looked at her work they saw glossy posters taken from the centerfold of teenage-pop-hero-worship magazines (targeted for a demographic echelon titled: »girls-fawning-over«), which they reasoned, Elizabeth had shifted into the higher gears of painting. À la Warhol. By now, this insight seems like low hanging fruit. Of course Elizabeth pays indulgences to Warhol (»Andy at the Factory«, 1997), but her work has become logically independent.

Either Elizabeth intentionally fails to differentiate personal from artistic sentiment, or simply cannot, and then nurtures this fusion from within the image of the cult-figure. From this vantage, she appears much closer in disposition to Ingres' uncanny passion for Raphael than Warhol's infamous blank slate of emotion. Like Ingres, her art springs from a cocktail of historical sources and personal inspiration which she deftly merges through her painting style. Now, think back to Ingres' portrait of Raphael with Fornarina. He relies on his subject's own self-portrait in the Uffizi, which Ingres knew and had copied. But the Fornarina picture is not simply a ›memento moiré‹ to Raphael. Rather, Ingres masterminded a fusion between himself and the object of his veneration via his own style and motif: the Renaissance artist's lover gazes out at us, adorned with an elegant turban taken directly from his own »Bathing Woman«, 1808 or perhaps »Grande Odalisque« of 1814. Ingres' own desire is spelled out: in token, he becomes Raphael's love object, the fantasy of reciprocal longing. Elizabeth comes to mind as Raphael willfully fails to make the distinction between personal and artistic sentiment. As a result the Fornarina picture is the beneficiary.

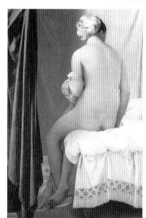

Jean Auguste-Dominique Ingres,
»Bathing Woman«, 1808

By design, Elizabeth adopts historical portraits with a wild range, from those with a zing for creating carefully tailored publicity, to the grainy and grimy paparazzi snapshots. Taking them to heart, she restores them with sentiment; she creates a personal relationship with them inside the act of painting. Her voice confirms what we can see: »There is no separation for me between people I know

immer dichter heran; natürlich denkt man in dem Zusammenhang an das Gemälde »Raffael und La Fornarina« von 1814. Ingres hatte bereits 1813 eine frühere Version der Fornarina gemalt, doch als sie verloren ging, malte er gleich im nächsten Jahr eine neue, und dieses Bild hängt nun im Fogg Art Museum in Harvard. Ich entdeckte es bei einem Spaziergang durch die Flure des Fogg zwischen meinen Vorlesungen, und hatte ich es zuvor auch nie leibhaftig gesehen, war es mir in Verbindung mit Elizabeth Peytons Schaffen schon oft durch den Kopf gegangen. 1813, das Jahr, in dem er selbst Madeleine Chapelle heiratete, malte Ingres Raffaels Verlobung mit der Nichte des Kardinals Bibiena und anschließend das Fornarina-Gemälde. Kein geringerer als Robert Rosenblum hat die Überlegung angestellt, ob der Zeitpunkt nur reiner Zufall war oder autobiografisch motiviert.

Das Fornarina-Gemälde ist relativ klein – etwa 60 Zentimeter breit und ebenso hoch – und wirkt dadurch recht intim. Fornarina, die Tochter eines Bäckers, war Raffaels Objekt der Anbetung gewesen, eine Liebesaffäre, die Ingres in- und auswendig kannte. Bis die neuere Forschung das Gemälde »La Fornarina« von 1516 Raffaels Schüler Giulio Romano zuschrieb, wurde allgemein angenommen, dass das Bild von Raffael stammt. Gewiss hielt Ingres es für einen Bestandteil von dessen Œuvre: In Ingres' Gemälde des Künstlers und seiner Geliebten von 1814 steht genau dieses Bild auf Raffaels Staffelei. So wie Ingres die Situation darstellt, hat Raffael Fornarina zwar fest umfasst, doch ist es ihr Bildnis, das den Künstler in seinen Bann gezogen hat. Er ist zwischen zwei Wahrheiten gefangen (und auch zwischen zwei Lieben) – Kunst und Wirklichkeit. In genau dem Moment, in dem diese beiden Welten beginnen, an ihren Rändern ineinander überzugehen, verschwindet die Frau in seinen Armen in ihrem idealisierten Abbild. Elizabeth Peyton gibt bereitwillig zu, das gleiche Dilemma zu haben. Gegenüber Francesco Bonami bemerkte sie: »Für mich gibt es keinen Unterschied zwischen Menschen, die ich durch ihre Musik oder durch Fotos kenne und jemandem, den ich persönlich kenne. Ich nehme sie ganz ähnlich wahr, insofern es keinen Unterschied zwischen den Eigenschaften gibt, die ich an ihnen inspirierend finde.«

Zwischendurch verwechselten zweitrangige Kritiker und erstrangige Fans die Ausstrahlung, die von Elizabeth Peytons Bildern ausging, mit einem echten »Teen Spirit«, der auf wundersame Weise in Kunst umgewandelt worden war. Wenn sie ihre Arbeiten anschauten, sahen sie doppelseitige Hochglanzposter aus Teenager-Pop-Helden-Verehrungsmagazinen (positioniert für eine demografische Zielgruppe namens: »Schwärmende Mädchen«), die, wie sie folgerten, Peyton in die höheren Sphären der Malerei hinauf katapultiert hatte. À la Warhol. Mittlerweile erscheint diese Sicht der Dinge arg vereinfachend. Selbstverständlich zollt die Künstlerin Warhol Tribut (»Andy at the Factory«, 1997), aber ihr Werk hat sich logisch davon befreit.

Entweder vermeidet Peyton absichtlich eine Differenzierung zwischen künstlerischem und persönlichem Gefühlsausdruck, oder sie kann schlichtweg nicht anders und nährt dann diese Verschmelzung der emotionalen Befindlichkeiten von innerhalb des Abbildes der Kultfigur. Daher scheint sie ihrem Wesen nach Ingres' unheimlicher Leidenschaft für Raffael viel näher zu stehen als Warhols berüchtigte Tabula rasa der Emotionen. Wie bei Ingres entspringt ihre Kunst einem Cocktail historischer Quellen und persönlicher Inspiration, die sie kraft ihres Malstils gekonnt miteinander verbindet. An dieser Stelle mag man sich noch einmal Ingres' Porträt von Raffael und Fornarina vor Augen führen. Er stützt sich dabei auf das Selbstporträt seines Sujets in den Uffizien, das Ingres kannte und kopiert hatte. Doch ist das Fornarina-Gemälde nicht einfach nur ein ›Memento moiré‹ zu Ehren Raffaels. Vielmehr hat Ingres eine Verschmelzung zwischen sich selbst und dem Objekt seiner Verehrung mittels

Raphael, »La Fornarina«, (attributed to Giulio Romano), 1516

through their music or photos,« she says, »and someone I know personally.« With the Fornarina painting under his arm, why would Ingres disagree?

Elizabeth's paintings take form well within the borders of her subjects: art, royalty, literature, sport, history, fashion, politics, and entertainment, permitting her own artistic sentiment to go forward from there synchronically. By her art, she allows her subjects, and their attendant historical contexts, to disap-

pear into one another: art into entertainment, entertainment into history, history into fashion and so on and so forth. And in the end, it is Elizabeth's sentiment that prevails above all. How else to explain pictures of Elvis and his mother, Oscar and Bosie, and the youngish Napoleon as venues of the same expression?

It must have been late in 1988 or perhaps it was in the year following that Elizabeth invited me to her studio to have a look. Like all the artists freshly out of school she lived in a shotgun apartment on the lower east side. She had given over the mini living room with bay windows to become her studio. Her pictures, tiny as they are, were all about, hung salon style. She was shy then, as she is shy now, and totally charming, and disarming, as she is now, and her fierce intelligence and abundant gifts she tried to disguise, but it never worked. Still doesn't. I was nose to nose with intimate pictures of Queen Elizabeth in Cambodia, some poet I do not recall, Napoleon, and then there was my favorite painting of the lot, François Mitterand, the sitting French President. Hands behind my back I turned asking, »Why string together these subjects? What does it mean, how does it add up?« She glanced down upon a stack of small drawings and watercolors and all but whispered:

Elizabeth Peyton, »Napoleon«, 1990

»I never paint anyone I do not admire.«

»That's it?«

»That's it.«

I worried in silence that it sounded all too flimsy. Though I did not realize it then, she was tenderly revealing to me that she had created a personal affair between herself and her subjects, famous and infamous to the last, individuals that she would never, ever come to know but by way of photography. The common thread was her buoyant admiration, a truth she could not conceal. And that was good enough. Elizabeth is of the generation who, above and beyond what my peers accomplished, fashioned an acceptable level of reality out of the media; they made their peace early on with photographs and all the rest. They were as real, these people in the photographs, as they would ever be for Elizabeth, and she was simply and perfectly content. There would never be the anxiety over the loss of the real, which traumatized my generation while issuing in its wake magnificent artists like Cindy Sherman, Louise Lawler, Sherrie Levine, David Salle, and Richard Prince. I recall leaving her studio somehow jealous.

Elizabeth Peyton, »Oscar and Bosie«, 1998

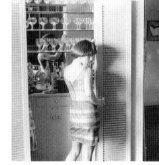

Cindy Sherman, »Untitled Filmstil # 49«, 1978

Weeks afterwards, I realized what I could not finger walking out of her studio: she had absorbed what my generation had brought about, and then took the step beyond. I grasped that Elizabeth was an imperfect realist. Ask the question: »What would deeply felt sentiment (something my generation all but officially condemned) expressed through portraiture from inside the media culture look like?« and the answer you get are Elizabeth's pictures. She is one of a very few in her generation to have been successful

des eigenen Stils und Motivs herbeigeführt: Die Geliebte des Renaissance-Künstlers blickt uns aus dem Bild heraus an, ausgestattet mit einem eleganten Turban, der direkt Ingres' eigenem Gemälde »Die Badende von Valpiçon« von 1808 oder vielleicht seinem Werk »Die große Odaliske« von 1814 entnommen ist. Ingres' eigenes Begehren nimmt Gestalt an: Symbolisch wird er zu Raffaels Liebesobjekt, der Wunschvorstellung wechselseitigen Verlangens. In Raffaels mutwilliger Aufhebung einer Unterscheidung zwischen persönlichem und künstlerischem Gefühlsausdruck kommt einem Elizabeth Peyton in den Sinn. Im Endeffekt profitiert das Fornarina-Gemälde davon.

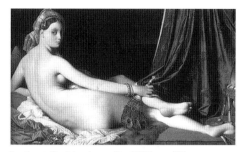

Jean Auguste-Dominique Ingres, »Grand Odalisque«, 1814

Mit Bedacht übernimmt Elizabeth Peyton eine bunte Palette historischer Porträts, angefangen bei denen, die das gewisse Etwas haben, um eine sorgfältig zugeschnittene Publicity zu erzeugen, bis hin zu den grobkörnigen, abgegriffenen Paparazzi-Schnappschüssen. Indem sie sich diese Vorlagen zu Herzen nimmt, stattet sie sie wieder mit Emotionalität aus: Im Akt der Malerei stellt sie eine persönliche Beziehung zu ihnen her. Ihre Stimme bestätigt das, was wir sehen können: »Für mich besteht kein Unterschied zwischen Menschen, die ich durch ihre Musik oder durch Fotos kenne«, sagt sie, »und jemandem, den ich persönlich kenne«. Mit dem Fornarina-Gemälde unterm Arm, warum sollte Ingres dem widersprechen?

Elizabeth Peytons Gemälde nimmt weit innerhalb der Grenzen ihrer Sujets Gestalt an: Kunst, das Königshaus, Literatur, Sport, Geschichte, Mode, Politik und Entertainment, was ihrem eigenen künstlerischen Sentiment gestattet, von dort aus synchronistisch voran zu schreiten. Durch ihre Kunst ermöglicht sie ihren Sujets und den mit ihnen verbundenen historischen Kontexten ineinander aufzugehen: Kunst geht in Entertainment auf, Entertainment in Geschichte, Geschichte in Mode und so weiter. Und am Ende setzen sich Peytons eigene Empfindungen allem anderen gegenüber durch. Wie sonst lassen sich Bilder von Elvis und seiner Mutter, Oscar und Bosie sowie dem jüngeren Napoleon als Schauplätze des gleichen künstlerischen Ausdrucks begreifen?

Es muss wohl Ende 1988 gewesen sein, oder vielleicht auch im darauf folgenden Jahr, als Elizabeth Peyton mich einlud, einen Blick in ihr Atelier zu werfen. Wie alle Künstler, die gerade frisch von der Hochschule kamen, lebte sie in einem abgetakelten Apartment auf der Lower East Side. Sie hatte das winzige Wohnzimmer mit seinen Erkerfenstern in ein Atelier umgewandelt. Ihre Bilder, so kleinformatig sie auch waren, hatte sie wie in einem Salon ganz dicht gehängt. Sie war damals schüchtern, genauso wie heute, und überaus charmant und entwaffnend, genauso wie heute, und sie versuchte ihre scharfe Intelligenz und ungeheure Begabung zu tarnen, was ihr nie gelang. Gelingt ihr immer noch nicht. Ich befand mich unmittelbar Nase an Nase mit intimen Porträts von Königin Elizabeth in Kambodscha, irgendeinem Dichter, der mir entfallen ist, sowie Napoleon, und dann gab es noch das Gemälde, das mir von allen am besten gefiel: François Mitterand, der französische Präsident in sitzender Haltung. Die Hände auf dem Rücken verschränkt, fragte ich sie, »Wieso diese Figuren miteinander verknüpfen? Was hat das für eine Bedeutung, wie passt das zusammen?« Sie blickte herunter auf einen Stapel kleiner Zeichnungen und Aquarelle und flüsterte fast:

Elizabeth Peyton, »Gladys and Elvis«, 1997

»Ich male niemanden, den ich nicht bewundere.«

»Ist das alles?«

»Das ist alles.«

investing in sentiment, deliberately sidestepping irony, and with a grand historical sweep. She is for portraiture what Carroll Dunham is for abstraction. But we are getting ahead of ourselves. To unfold these ideas let me begin with an extended quote from Morse Peckman's essay »Toward a Theory of Romanticism«, for it is indeed toward such a theory, circa 2001, we now embark. Elizabeth was born more than a decade after Peckman's piece of writing was published in 1951, but if you are of a certain age, and possess a certain sort of education you will recall Peckman's work and the way it leaned heavily on your judgment. In its pages he wrote:

»Perfection ceases to be a positive value. Imperfection becomes a positive value. Since the universe is changing and growing, there is consequently a positive and radical intrusion of novelty into the world. That is, with intrusion of each novelty, the fundamental character of the universe itself changes. We have a universe of emergents. If all these things be true, it therefore follows that there are no pre-existent pat-

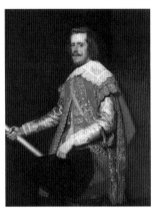

Diego Velázquez,
»King Philip IV of Spain«, 1644

terns. Every work of art, for instance, creates a new pattern; each one has its own aesthetic law. It may have resemblances even in principle to previous works of art, but fundamentally it is unique. Hence come two derivative ideas. First, diversitarianism, not uniformitarianism, becomes the principle of both creation and criticism. The Romantics, for example, have been accused of confusing genres of poetry. Why shouldn't they? The whole metaphysical foundation of the genres had been abandoned, or for some authors had simply disappeared. The second derivative is the idea of creative originality. True, the idea of originality had existed before, but in a different sense. Now the artist is original because he is the instrument whereby a genuine novelty, an emergent, is introduced into the world, not because he has come with the aid of genius a little closer to previously existent patterns, natural and divine.«

»An essential difference exists between making a picture of someone and making a portrait!« I recall this proclamation word for word, though I haven't the slightest clue who declared it during my instruction in the gray and airless ways of Art Historical Methodology. I have never been to Catechism, but intuition tells me that the seminar in Art Historical Methodology is exactly like Catechism, whatever Catechism actually is. Where portraiture is concerned – we were told – the subject sits for a ›portrait‹, and in every other instance it is plain old picture-making. Ingres, for example, made a picture of Raphael, while Velásquez made a portrait of King Philip IV of Spain. Simply said, Elizabeth has conflated the two, and along the way sustained Peckman, while overruling my tutoring in the methods of the history of art.

Her generation has accepted the logic that goes: in some instances, a photograph of the moon for example, or Raphael's self-portrait in the Uffizi, the picture becomes an inescapable expression of reality, because it is as close to the real as you will ever come, and so by default exists as an acceptable level of reality. Relativity reigns. The age of portraiture as Raphael and Ingres could appreciate it has passed. You may resist, you may wish it to be otherwise, you may rage against the loss of ›the real‹, but in the end, the cultural register measuring the real has realigned. And in this respect, this little piece of logic, and therefore history are inescapable. Note to my generation: it never was the case that the real was lost, it simply came to exist in different degrees or kind; nothing one does after photography will restore the previous culture. My generation reacted to the aftershocks of photography mistaking them for a shortfall; Elizabeth's generation accepted all of it for what it was. And of course they could; Sherman and Prince's critical insight cut a wide path and cleared a site near culture's edge where Elizabeth, and Richard Phillips, and Lisa Yuskavage practice their art. Hindsight is marvelous.

Schweigend sinnierte ich darüber, dass das allzu dürftig klang. Obwohl ich es damals nicht realisierte, offenbarte sie mir auf sanfte Art, dass sie ein persönliches Verhältnis zwischen sich und ihren Sujets hergestellt hatte, die – berühmt oder berüchtigt –, bis zur letzten Figur Individuen waren, die sie niemals im Leben kennenlernen würde, außer auf dem Wege von Fotografien. Der gemeinsame Faden, der die Figuren verband, war die lebhafte Bewunderung der Künstlerin für sie, eine Tatsache, die sie nicht verbergen konnte. Und das war gut genug. Elizabeth Peyton kommt aus der Generation, die weit über das hinaus, was meine Altersgenossen vollbrachten, eine akzeptable Ebene der Realität aus den Medien heraus geschaffen haben; sie haben schon frühzeitig ihren Frieden mit der Fotografie und all dem anderen geschlossen. Die Menschen in den Fotografien waren so real wie sie es je für Elizabeth Peyton sein würden, und damit war sie ganz einfach vollkommen zufrieden. Es würde für sie nie die Furcht vor dem Verlust des Realen geben, die meine Generation traumatisiert hatte, während daraus zugleich hervorragende Künstlerinnen und Künstler wie Cindy Sherman, Louise Lawler, Sherrie Levine, David Salle und Richard Prince erwachsen sind. Ich erinnere mich, dass ich ihr Atelier mit einem gewissen Gefühl von Neid verließ.

Richard Prince, »Untitled (hand with cigarette)«, 2001

Wochen später wurde mir klar, was ich beim Verlassen ihres Ateliers nicht genau hatte fixieren können: Sie hatte das aufgesogen, was meine Generation umgesetzt hatte, und war dann noch einen entscheidenden Schritt weiter gegangen. Ich begriff, dass Elizabeth Peyton eine unvollkommene Realistin war. Würde man die Frage stellen: »Wie sieht tief empfundenes Gefühl aus (etwas, was meine Generation so gut wie offiziell verdammte), das mittels der Porträtmalerei aus dem Inneren der Medienkultur heraus ausgedrückt wird?«, dann wären die Bilder der Künstlerin die Antwort darauf. Sie ist eine von sehr wenigen ihrer Generation, die erfolgreich Emotionen eingesetzt, dabei bewusst auf Ironie verzichtet und einen ausgreifenden historischen Bogen gespannt hat. Für die Gattung des Porträts ist Peyton das, was Carroll Dunham für die abstrakte Malerei ist. Aber wir eilen uns selbst voraus. Um diese Gedanken zu entfalten, möchte ich zunächst mit einem ausgedehnten Zitat von Morse Peckmans Essay »Toward a Theory of Romanticism« beginnen, denn tatsächlich befinden wir uns jetzt, um 2001 herum, im Aufbruch zu einer solchen Theorie der Romantik. Elizabeth Peyton wurde über ein Jahrzehnt nach Erscheinen von Peckmans Text, der 1951 veröffentlicht wurde, geboren. Wenn man jedoch über ein bestimmtes Alter verfügt und eine bestimmte Art von Bildung genossen hat, wird man sich an Peckmans Untersuchung erinnern und auch daran, wie stark sie das eigene Urteil prägte. In seinem Werk schrieb er:

»Vollkommenheit ist kein positiver Wert mehr. Unvollkommenheit wird zu einem positiven Wert. Da das Universum in ständigem Wandel und Wachstum begriffen ist, ergibt sich daraus ein positives und radikales Eindringen des Neuen in die Welt hinein. Das heißt, mit jedem Eindringen des Neuen verändert sich das fundamentale Wesen des Universums selbst. Wir haben ein Universum des unvorhersehbar Entstehenden. Entspricht dies alles der Wahrheit, gibt es folglich keine vorgegebenen Muster. Jedes Kunstwerk, beispielsweise, schafft ein neues Muster; jedes folgt seiner eigenen ästhetischen Gesetzmäßigkeit. Es kann zwar Ähnlichkeiten, sogar prinzipieller Art, mit vorhergehenden Kunstwerken haben, aber grundsätzlich ist es einmalig. Daraus lassen sich zwei Gedanken ableiten. Erstens: Diversifizierung, statt Uniformisierung, wird zum Prinzip sowohl des kreativen Schaffens als auch der Kritik. Den Romantikern, beispielsweise, wurde vorgeworfen, die Gattungen der Dichtung durcheinander zu bringen. Wieso sollten sie dies nicht tun? Die gesamte metaphysische Grundlage der Gattungen war aufgegeben worden oder hatte sich für einige Autoren einfach aufgelöst. Der zweite

This logic is one thing, but the implications of the logic, where Elizabeth's work is concerned, create a much grander statement, and more profound, for remarkably she qualifies as a Romantic under Peckman's theory, and moreover her art succeeds as an original expression (something else my generation all but officially condemned). Not an original or Romantic expression as understood in the old order –

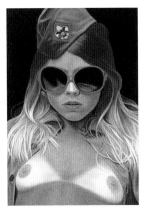

the yoke my generation tossed off – but an original expression willfully operating under the influence of media. How is it original? It is not original in the sense that her effete-looking subjects or her painterly style are free from precedent. Nor is originality in play because of her unabashed sincerity, which she gladly shares with Ingres and others. But the history of portraiture makes Elizabeth's art an intrusion, as Peckman would explain it. Peckman celebrates the Romantics he obviously adores, for confusing poetry's genres to create their own interference, and while I would object to the word ›confusing‹ where Elizabeth is concerned, it is true that history has provided her with an instrument that fails to differentiate between portraiture and picture-making, which implies a great deal about our cultural course.

I am just now thinking of a small ink and wash drawing from 1993. Its fluid style causes me to recall the pictures I first saw in Elizabeth's studio more than a decade ago. It is unique. Unless I have inadvertently passed over another example, it is the single picture where one of Elizabeth's subjects is captured in the act of admiring a work of art. In this case, Queen Elizabeth stands before a jumbo-sized painting of her ancestors Victoria and Albert that had been produced for the Royal household by Franz Xaver Winterhalter in 1846. Winterhalter, who painted most of Europe's royalty, was preferred by Victoria above all other portrait painters. She went so far as to have a copy of the 1846 Winterhalter portrait commissioned so that she and Albert could enjoy it while at Osborne House.

Seen at the extreme left of the small drawing, Her Royal Highness seems positively imperial in a long formal gown. She holds a brochure, likely the exhibition guide that would tell her what she already knows all too well about these members of her Royal family. With an economy of means Elizabeth conveys what must have fascinated her about the photograph in the first instance: the uncomplicated veneration seen across the Queen's face. One nearly hears her sigh.

For the Royal household's communication with the press, this photo-opportunity is simplicity itself. With elegance and aplomb it registers heritage, the »it« subject for all Royals. Inheritance, birthright, legacy, bequest are spoken in a single image as past and present meet for the cameras. But it also registers the end of the line where the history of portraiture is concerned. The original photograph of the Queen enchanted has eclipsed the function of the very painting she visually coddles. And while it is certainly true that Dukes and Queens still sit for the occasional painted portrait, it is just as true that official photographs issuing from Buckingham Palace have usurped the purpose of the very portrait painting the Queen reveres. In the painting, the young Prince relaxing near his mother and observed by his father was the assurance that the Realm would survive. And now, Queen Elizabeth, appearing deferential before this particular portrait, repeats the Royal pledge to her subjects. In this light, portrait painting has become a prop, appearing out of place and out of date.

Looking over the shoulder of the Queen, gazing into her past, we cannot miss the point that for the purposes of the press photograph she is meant to appear unable to separate people she can only know through a portrait from their descendants (herself). And then, given the same opportunity to look over Elizabeth's shoulder while she gazes at the Queen looking deep into the painting of her lineage, the same failure to distinguish between the realities of art and life repeats itself in an ever-telescoping rapport.

Gedanke ist die Vorstellung von schöpferischer Originalität. Sicher, die Vorstellung von Originalität existierte bereits vorher, aber auf andere Weise. Jetzt ist der Künstler originell, weil er das Instrument ist, durch das etwas genuin Neues, ein Emergent, in die Welt hinein gebracht wird, und nicht, weil er mit Hilfe genialer Schöpferkraft bereits bestehenden Mustern – natürlichen und göttlichen – etwas näher gekommen ist.«

»Ein essenzieller Unterschied besteht zwischen der Anfertigung eines Bildes und der Anfertigung eines Porträts von einem Menschen!« Wort für Wort ist mir dieser Ausspruch in Erinnerung geblieben, obwohl ich nicht die leiseste Ahnung habe, wer ihn während meiner Unterweisung in den grauen, stickigen Gedankenbahnen der kunsthistorischen Methodik von sich gegeben hat. Ich habe noch nie den Katechismus studiert, doch sagt mir meine Intuition, dass kunsthistorische Methodik genauso ist wie der Katechismus, was immer der auch genau sein mag. In Bezug auf die Porträtmalerei wurde uns gesagt, dass in diesem Fall eine Person Modell für das ›Porträt‹ eines Malers sitzt und dass es in jedem anderen Fall einfach nur gute alte Malerei sei. Ingres, beispielsweise, hat von Raffael ein Bild geschaffen, während Velázquez von König Philip IV. von Spanien ein Porträt anfertigte. Simpel ausgedrückt hat Elizabeth Peyton die beiden Ansätze zusammengefasst und auf dem Wege Peckman bestätigt, während sie meine Schulung in den Methoden der Kunstgeschichte umgestoßen hat.

Ihre Generation hat die Logik akzeptiert, die da lautet: In manchen Fällen – einer Fotografie des Mondes, beispielsweise, oder Raffaels Selbstporträt in den Uffizien – wird das Bild zu einem unabdingbaren Ausdruck der Realität, weil es so dicht am Realen ist, wie man überhaupt je gelangen kann. Es existiert deshalb aus Ermangelung einer besseren als akzeptable Ebene der Realität. Es herrscht Relativität. Das Zeitalter der Porträtmalerei, wie Raffael und Ingres es wahrnehmen konnten, ist vorüber. Man mag sich dagegen sträuben, man mag es sich anders wünschen, man mag sich wütend gegen den Verlust des ›Realen‹ wenden, aber am Ende hat sich die kulturelle Messlatte, die das Reale berechnet, neu ausgerichtet. Und in dieser Hinsicht ist diese logische Schlussfolgerung und somit auch der Lauf der Geschichte unvermeidlich. Anmerkung für meine Generation: Das Reale war nie verloren gegangen, sondern hat nur in anderen Abstufungen oder in anderer Form Gestalt angenommen; nichts, was man nach dem Auftreten der Fotografie vollbringt, wird die vorherige Kultur wieder herstellen. Meine Generation reagierte auf die Nachbeben der Fotografie und hielt sie fälschlicherweise für ein Defizit; Elizabeth Peytons Generation nahm all diese Dinge für bare Münze an. Und natürlich konnte sie dies auch tun; Shermans und Prince' kritisches Verständnis hatte einen breiten Weg gebahnt und einen Platz am Rande der Kultur frei geschlagen, wo Elizabeth Peyton, Richard Phillips und Lisa Yuskavage ihre Kunst praktizieren. Im Nachhinein ist man immer viel klüger.

Diese logische Folgerung ist eine Sache, doch führen die Implikationen dieser Logik, wenn es um Peytons Arbeiten geht, zu einer viel umfassenderen und profunderen Aussage, denn bemerkenswerterweise qualifiziert sich die Künstlerin im Rahmen von Peckmans Theorie als Romantikerin. Und darüber hinaus funktioniert ihre Kunst als originärer schöpferischer Ausdruck (noch etwas, was meine Generation so gut wie offiziell verdammte). Nicht als originärer oder romantischer schöpferischer Ausdruck dergestalt, wie er innerhalb der alten Weltordnung begriffen wurde – das Joch, das meine Generation abgeschüttelt hatte –, sondern als eine originäre Ausdrucksform, die bewusst unter dem Einfluss der Medien operiert. Inwiefern ist die Künstlerin originell? Sie ist es nicht in dem Sinne, dass ihre fragilen Figuren oder ihr Malstil ohne Vorläufer wären. Ebenso wenig kommt hier Originalität ins Spiel aufgrund ihrer unerschrockenen Aufrichtigkeit, die sie fröhlich mit Ingres und anderen teilt. Doch lässt die Geschichte der Porträtmalerei Elizabeth Peytons Kunst zu einem Eindringen im Sinne

The Queen stands in relation to her culture as Elizabeth to her own. For the Queen, it is Victoria and Albert, for Elizabeth is it Her Royal Highness, or Kurt Cobain or Oscar Wilde. They are both; Queen and artist absorbed by a level of veneration that refits nominal definitions of the real, but neither of them had any other choice were they to perform their work as Queen and as artist creating a belief system out of symbols. In this regard, the small drawing becomes a majestic schema for how Elizabeth's art makes meaning. My original question posed in her studio years before has found its answer, and the

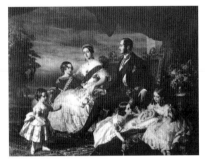

Franz Xaver Winterhalter,
»Queen Victoria and her family«, 1846

reason I would never think of Elizabeth's art without Ingres' painting »Raphael and The Fornarina« coming to mind is made explicit. Elizabeth has captured the Queen in the role Ingres once reserved for Raphael, and in the same gesture, gives in to her own compulsion and desire to make personal contact through veneration. But this is hardly a matter of paranormal idol worship as it nearly was with Ingres; rather it is an expression of emotional engagement circa 2001.

I think back to Peckman's notion of disappearing genres and originality, where he wrote:

»The whole metaphysical foundation of the genres had been abandoned, or for some authors had simply disappeared. The second derivative is the idea of creative originality. True, the idea of originality had existed before, but in a different sense. Now the artist is original because he is the instrument whereby a genuine novelty, an emergent, is introduced into the world, not because he has come with the aid of genius a little closer to previously existent patterns, natural and divine.«

And so, Elizabeth's appreciation of personal contact breathes life into portraiture once the conventional genres of the portrait and the picture have disappeared into one another, allowing her emotional engagement with her subject free reign, expanding in the vacuum of anonymity our media culture peddles in a global economy of images. For Elizabeth, her culture could not make sense other than by seeing the genres vanish. She has restored the personal and eccentric, where there was none, proving that a longed-for excess of emotional attachment can arise, though moments before we could only see a deficiency. Her art is purely Romantic in this sense, a revival of idealism, and a revolt from reason.

Peckmans werden. Peckman zelebriert die Romantiker, die er offensichtlich zutiefst dafür verehrt, dass sie die Gattungen der Dichtung durcheinander brachten, um somit ihre eigene Störung zu verursachen. Und während ich in Elizabeth Peytons Fall von dem Begriff ›durcheinander bringen‹ absehen würde, ist es wahr, dass die Geschichte sie mit einem Instrument ausgestattet hat, das keine Unterscheidung zwischen dem Verfassen eines Porträts und eines Bildes macht, was wiederum eine Menge über den Kurs aussagt, auf dem sich unsere Kultur befindet.

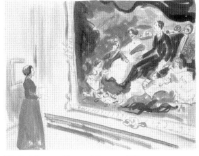

Elizabeth Peyton, »Kings and Queens«, 1993

Ich denke gerade in diesem Moment an eine kleine Tuschzeichnung von 1993. Ihre fließende Gestaltung ruft mir die Bilder ins Gedächtnis zurück, die ich zuerst vor über zehn Jahren in Elizabeth Peytons Atelier sah. Diese Zeichnung ist einzigartig. Wenn ich nicht versehentlich ein weiteres Beispiel übergangen habe, dann ist es das einzige Bild, in dem das Sujet der Künstlerin bei der Betrachtung eines Kunstwerks eingefangen ist. In diesem Fall steht Königin Elizabeth vor einem riesigen Gemälde ihrer Vorfahren Victoria und Albert, das Franz Xaver Winterhalter 1846 für die königliche Familie schuf. Königin Victoria zog Winterhalter, der die meisten europäischen Fürstenhäuser gemalt hat, allen anderen Porträtmalern vor. Sie ging so weit, eine Kopie des Winterhalter-Porträts von 1846 in Auftrag zu geben, damit sie und Albert sich bei ihren Aufenthalten im Osborne House daran erfreuen konnten.

Extrem links in der kleinen Zeichnung zu sehen, wirkt die Queen ausgesprochen hoheitsvoll in langer, festlicher Robe. Sie hält eine Broschüre in der Hand, vermutlich der Ausstellungsführer, der sie über das informiert, was ihr hinsichtlich dieser Mitglieder ihrer königlichen Familie schon bestens bekannt sein dürfte. Mit einer Ökonomie der Mittel drückt die Künstlerin das aus, was sie zuerst an der fotografischen Vorlage fasziniert haben muss: die unverhohlene Bewunderung, die in Königin Elizabeths Gesicht sichtbar ist. Man kann sie beinah seufzen hören.

Was die Kommunikation des königlichen Haushaltes mit der Presse anbelangt, ist dieses Foto-Ereignis auf die denkbar einfachste Aussage reduziert. Mit Eleganz und Gelassenheit registriert es Herkunft – für alle Royals das Thema schlechthin. Erbe, Geburtsrecht, Vermächtnis, Hinterlassenschaft werden in einem einzigen Bild ausgedrückt, als Vergangenheit und Gegenwart für die Kameras aufeinander treffen. Doch registriert das Foto auch das Ende einer langen Linie in Bezug auf die Geschichte der Porträtmalerei. Das Originalfoto der verzauberten Königin hat die Funktion genau des Gemäldes in den Schatten gestellt, das sie mit dem Blick liebkost. Und während es durchaus der Wahrheit entspricht, dass Herzöge und Königinnen für das gelegentliche gemalte Porträt still sitzen, entspricht es ebenso der Wahrheit, dass die offiziellen Fotografien, die vom Buckingham Palace ausgegeben werden, den Zweck des nämlichen Porträtgemäldes usurpiert haben, das die Königin verehrt. Im Gemälde bedeutete der junge Prinz, der sich in der Nähe seiner Mutter entspannt und vom Vater beobachtet wird, die Zusicherung, dass das Königreich fortbestehen würde. Und nun wiederholt Queen Elizabeth, die vor diesem bestimmten Porträt ehrerbietig in Erscheinung tritt, das königliche Versprechen an ihre Untertanen. In diesem Licht ist die Porträtmalerei zum Requisit geworden, das überholt und deplaziert wirkt.

Schauen wir der Königin über die Schulter und in ihre Vergangenheit hinein, wird uns kaum entgehen, dass sie zum Zweck des Pressefotos so erscheinen soll, als könne sie die Menschen, die sie nur von einem Porträt her kennen kann, nicht von deren Nachkommen (sich selbst) unterscheiden. Und dann – die Möglichkeit vorausgesetzt, ebenso über Elizabeth Peytons Schulter blicken zu können, während sie die Königin betrachtet, die sich in das Gemälde von ihrer Familie vertieft – wiederholt

sich das gleiche Unvermögen, zwischen den Realitäten von Kunst und Leben zu unterscheiden, in endloser Fortsetzung. Die Königin steht in Beziehung zu ihrer Kultur wie Elizabeth Peyton zu ihrer eigenen. Für die Königin sind das Victoria und Albert, für die Künstlerin Queen Elizabeth, oder Kurt Cobain, oder Oscar Wilde. Sie sind beides; Königin und Künstlerin absorbiert von einer Ebene der Verehrung, die die nominellen Definitionen des Realen wieder instand setzt. Doch keine von ihnen hätte eine andere Wahl in der Ausführung ihrer Aufgaben als Königin und Künstlerin, ein Glaubenssystem aus Symbolen zu erschaffen. In dieser Hinsicht wird die kleine Zeichnung zum majestätischen Schema für die Art und Weise, wie Elizabeth Peytons Kunst Bedeutung erzeugt. Meine ursprüngliche Frage, die ich damals vor Jahren in ihrem Atelier stellte, hat eine Antwort gefunden, und der Grund, warum es mir unmöglich ist, über Peytons Kunst zu reflektieren, ohne dass mir Ingres' Gemälde »Raffael und La Fornarina« in den Sinn kommt, wird deutlich. Elizabeth Peyton hat die Königin in der Rolle eingefangen, die Ingres einst für Raffael reservierte, und gibt mit der gleichen Geste ihrem eigenen inneren Drang und Verlangen nach, persönlichen Kontakt durch den Akt der Verehrung herzustellen. Doch ist dies kaum eine Frage paranormaler Idol-Verehrung, wie das fast schon bei Ingres der Fall war; vielmehr ist es ein Ausdruck emotionalen Engagements ungefähr im Jahr 2001.

Ich denke noch einmal an Peckmans Vorstellungen von verschwindenden Gattungen und Originalität zurück, wo er schrieb:

»Die gesamte metaphysische Grundlage der Gattungen war aufgegeben worden, oder war für einige Autoren einfach verschwunden. Der zweite Gedanke ist die Vorstellung von schöpferischer Originalität. Sicher, die Vorstellung von Originalität existierte bereits vorher, aber auf andere Weise. Jetzt ist der Künstler originell, weil er das Instrument ist, durch das etwas genuin Neues, ein Emergent, in die Welt hinein gebracht wird, und nicht, weil er mit Hilfe genialer Schöpferkraft bereits bestehenden Mustern – natürlichen und göttlichen – etwas näher gekommen ist.«

Und somit haucht Elizabeth Peytons Freude an persönlichem Kontakt der Porträtmalerei wieder neues Leben ein, sind erst einmal die konventionellen Gattungen des Porträts und des Gemäldes ineinander aufgegangen, was ihrem emotionalen Engagement für ihr Sujet freie Hand gewährt, das sich im Vakuum der Anonymität ausdehnt, mit dem unsere Medienkultur in einer globalen Ökonomie der Bilder hausieren geht. Für die Künstlerin kann ihre Kultur überhaupt nur Sinn ergeben, wenn sich die Gattungen auflösen. Sie hat das Persönliche und Exzentrische dort wieder hergestellt, wo es dieses nicht gab, und dabei bewiesen, dass ein ersehntes Übermaß an emotionaler Zugehörigkeit entstehen kann, selbst wenn wir nur Augenblicke zuvor lediglich ein Defizit erkennen konnten. In dieser Hinsicht ist ihre Kunst ganz und gar romantisch, ein Revival des Idealismus, und ein Aufstand gegen die Vernunft.

Bildteil
Plates

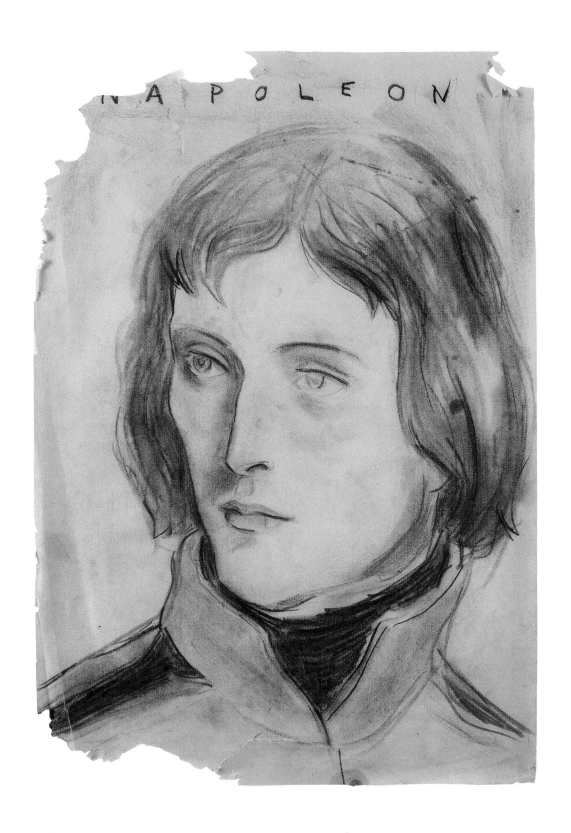

»Napoleon«, 1990, charcoal on paper, 56 x 45,7 cm Sadie Coles HQ, London

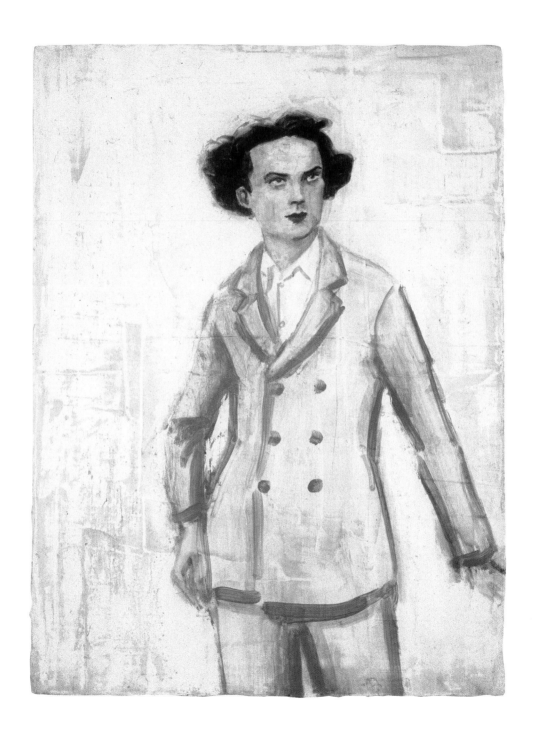

26

»Ludwig II«, 1994, oil on board, 43,2 x 30,5 cm Los Angeles County Museum of Art

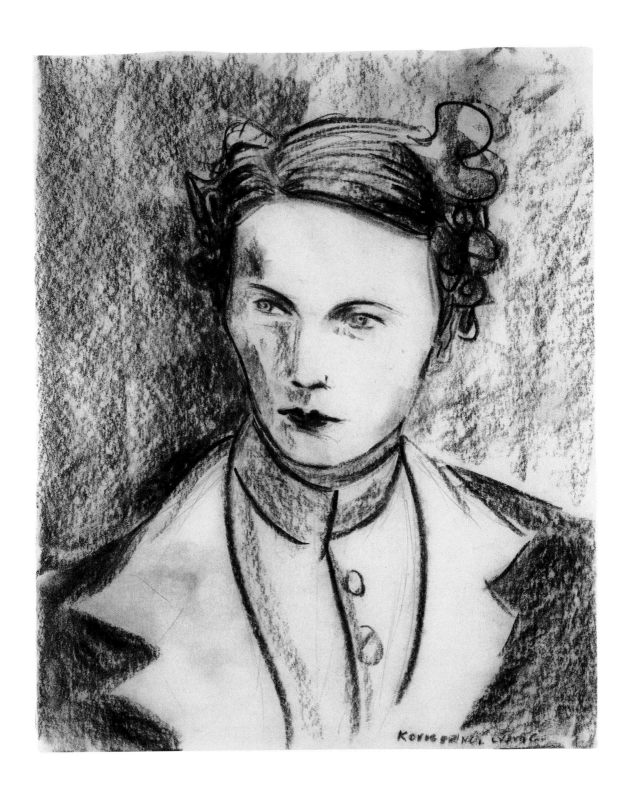

»Crown Prince Ludwig«, 1995, charcoal on paper, 33,5 x 28 cm Private Collection, Hamburg

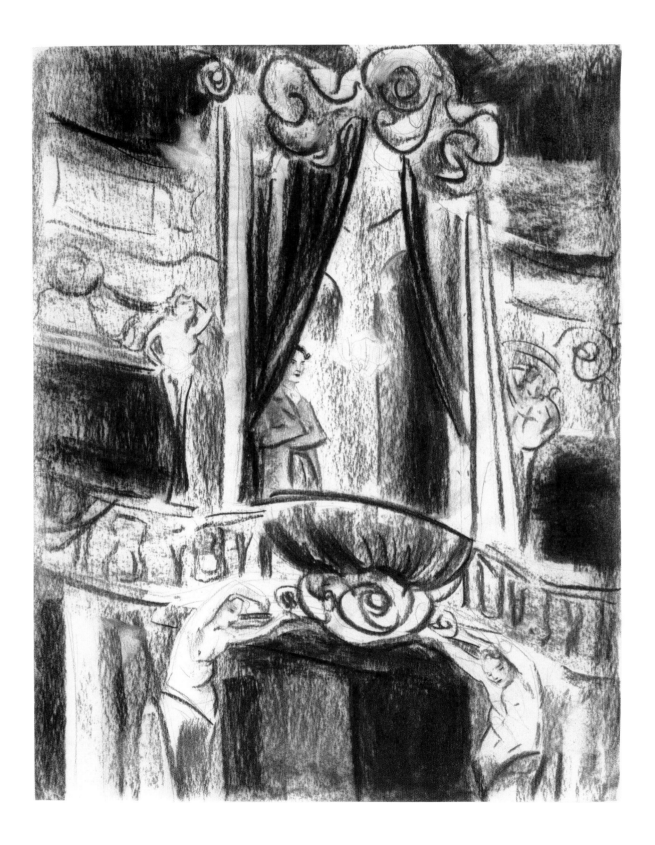

»Ludwig in the Residence Court Theatre«, 1995, charcoal on paper, 43,2 x 35,6 cm Collection Andrea Rosen

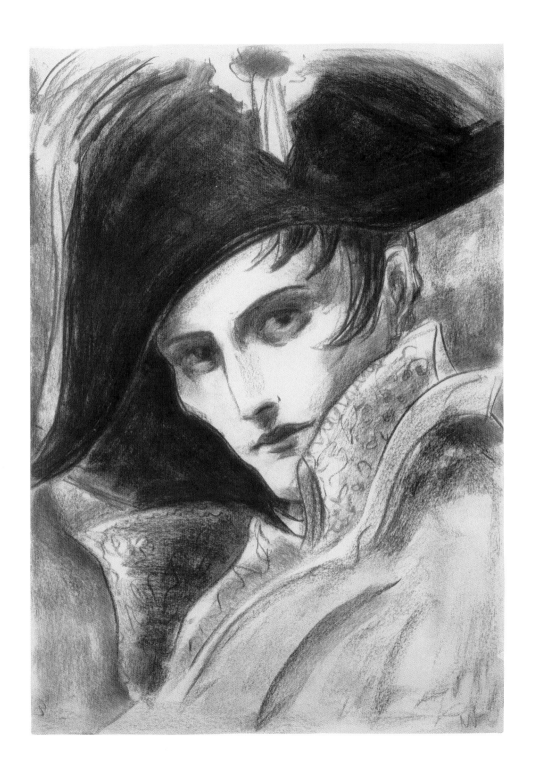

»Napoleon«, 1995, charcoal on paper, 41,9 x 29,8 cm Susan & Michael Hort

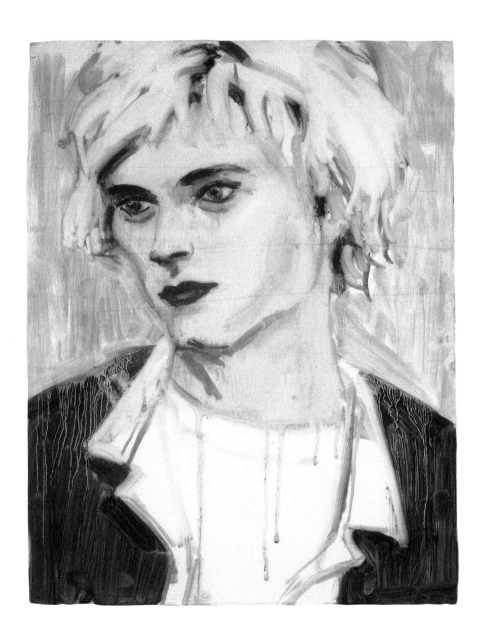

»Zoe's Kurt«, 1995, oil on board, 35,6 x 27,9 cm Collection Zoe Stillpass

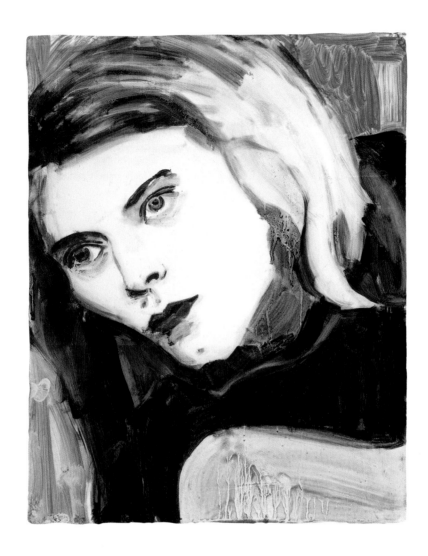

»Kurt«, 1995, oil on board, 25,4 x 20,3 cm Private Collection, New York

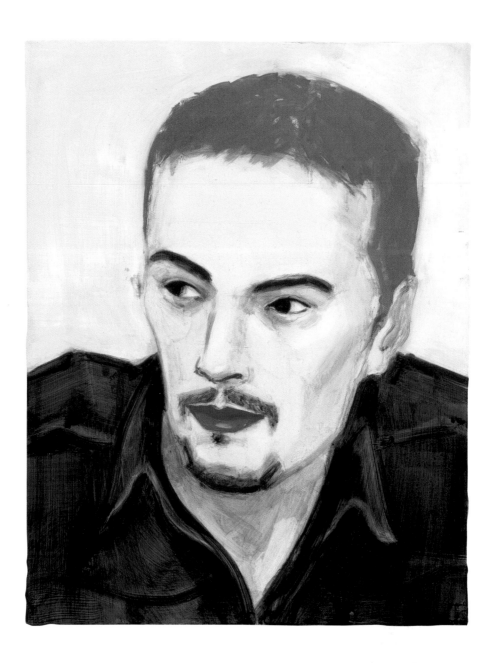

»Jake Chapman«, 1995, oil on board, 35,6 x 27,9 cm Private Collection, Berlin, Courtesy Neugerriemschneider, Berlin

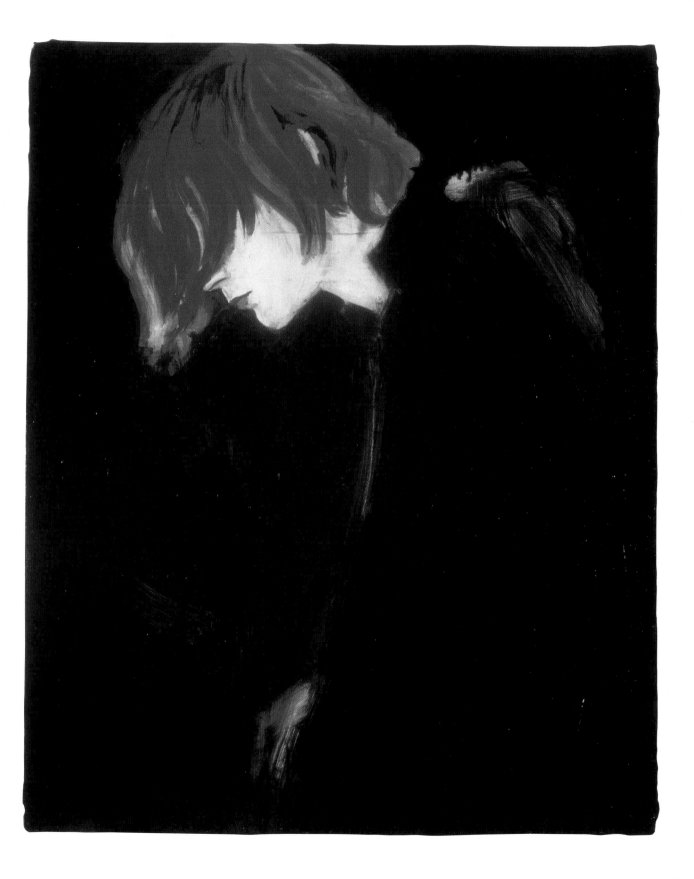

»Alizeran Kurt«, 1995, oil on canvas, 61 x 50,8 cm Collection John McEnroe, New York, Courtesy David Zwirner, New York

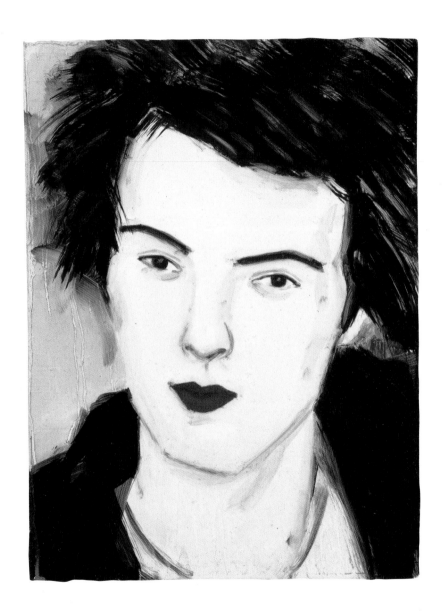

»Sid Vicious«, 1995, oil on board, 30,5 x 22,9 cm Museum of Fine Arts, Boston

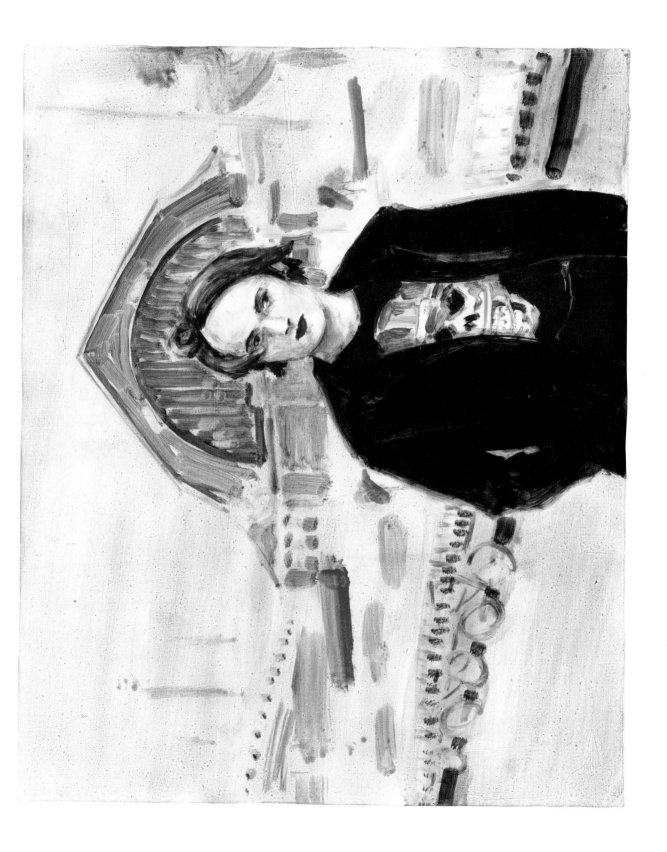

»Franz outside the Deichtorhallen«, 1995, oil on board, 34,8 x 43 cm André & Joceline Gordts-Vanthoumont, Belgium

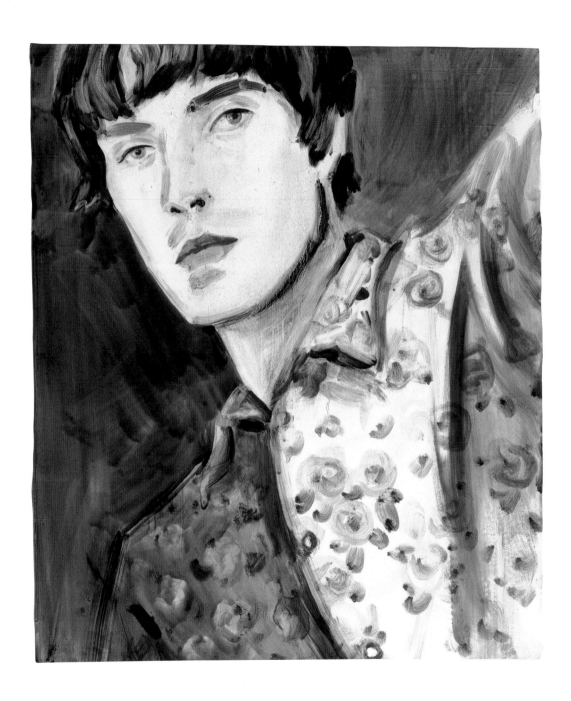

»Flower Liam«, 1996, oil on board, 50,8 x 40,6 cm Private Collection

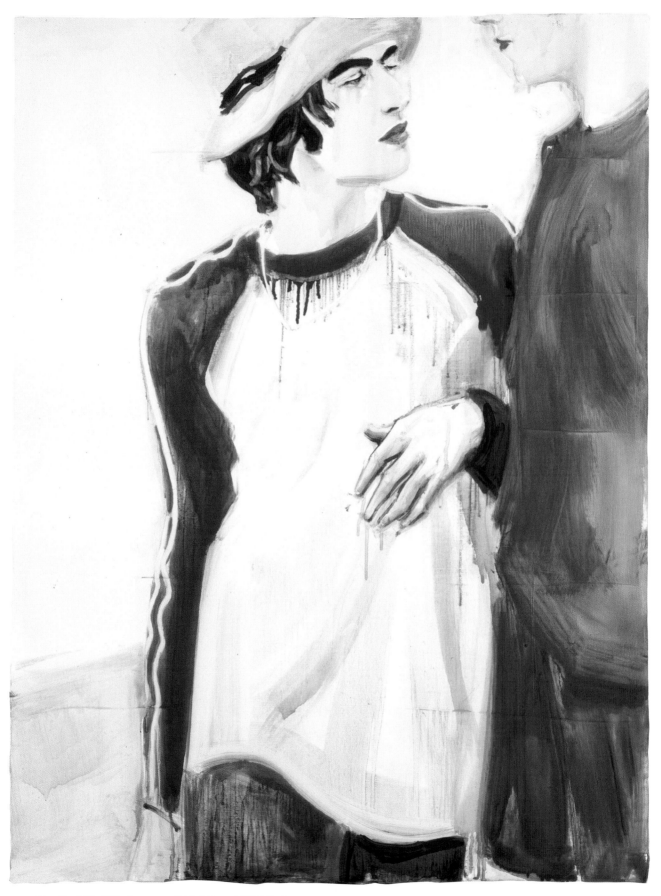

»Liam (Football)«, 1996, oil on canvas, 101,6 x 76,2 cm EVN Collection

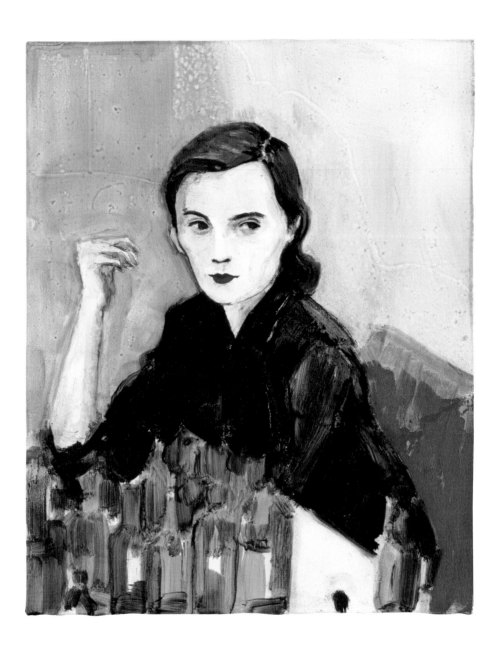

»Sharon (Berlin)«, 1996, oil on board, 25,4 x 20,3 cm Private Collection

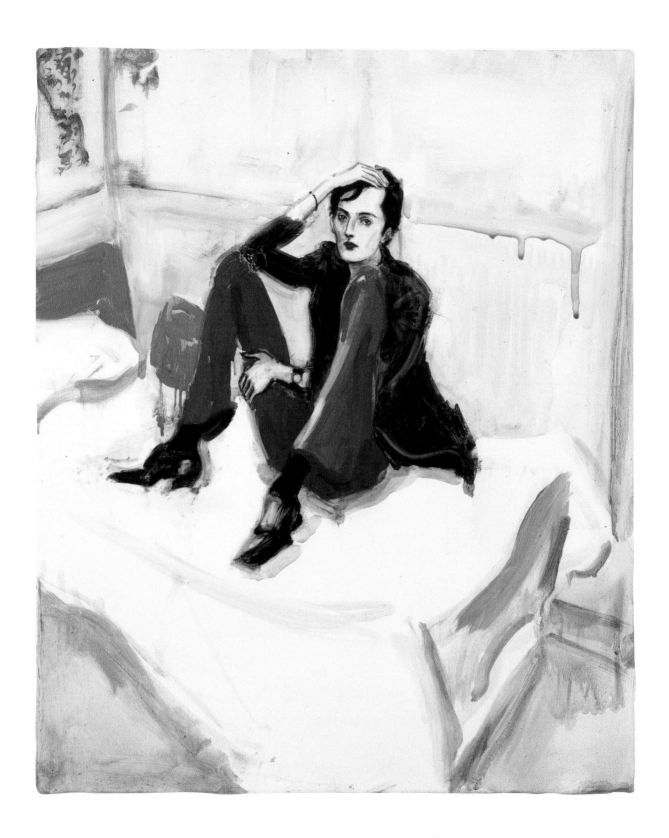

»Jarvis on bed«, 1996, oil on board, 43,2 x 35,6 cm Laura Steinberg Tisch

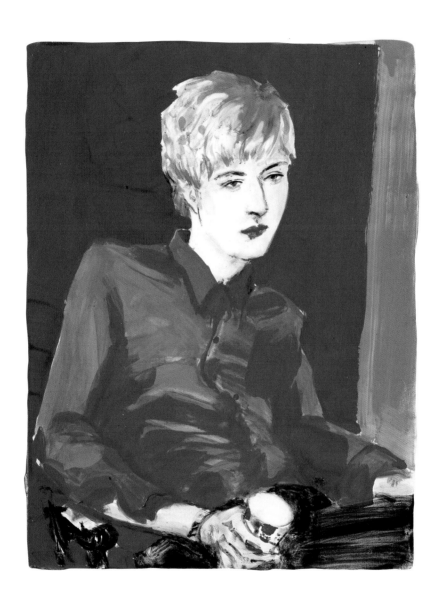

»Piotr«, 1996, oil on board, 22,9 x 12,7 cm Collection of the artist

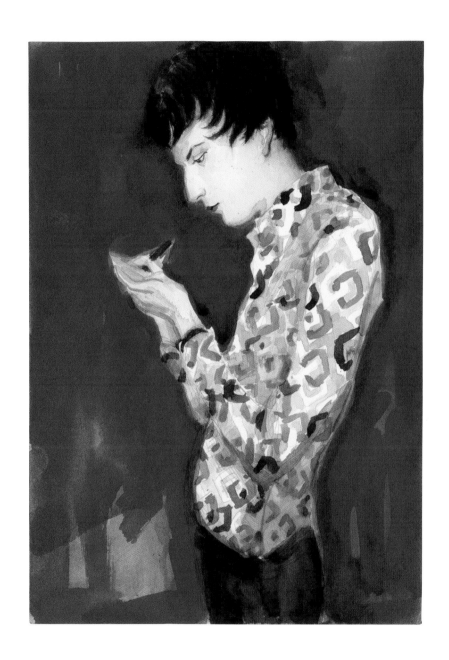

»Jarvis«, 1996, watercolour on paper, 25,4 x 17,8 cm Collection Monica de Cardenas, Milano

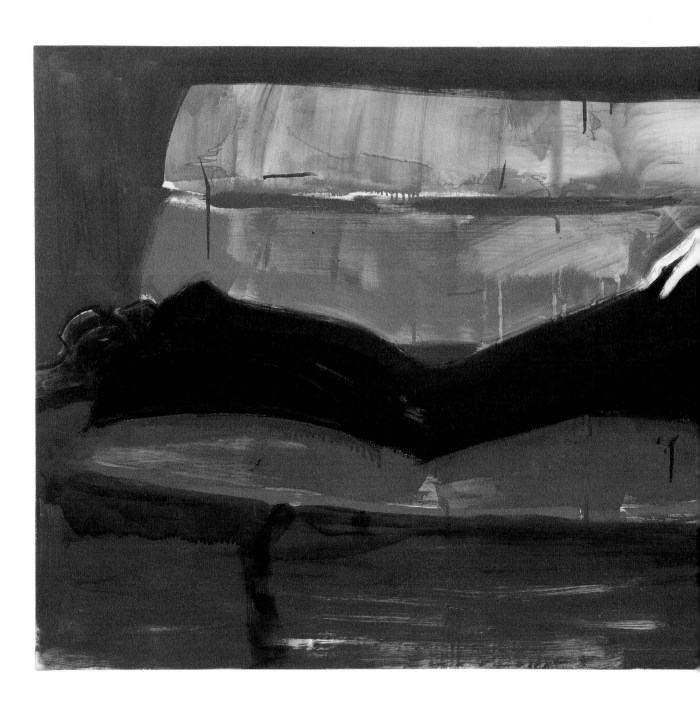

»Piotr«, 1996, oil on canvas, 96,5 x 218,4 cm Collection Nina & Frank Moore, New York

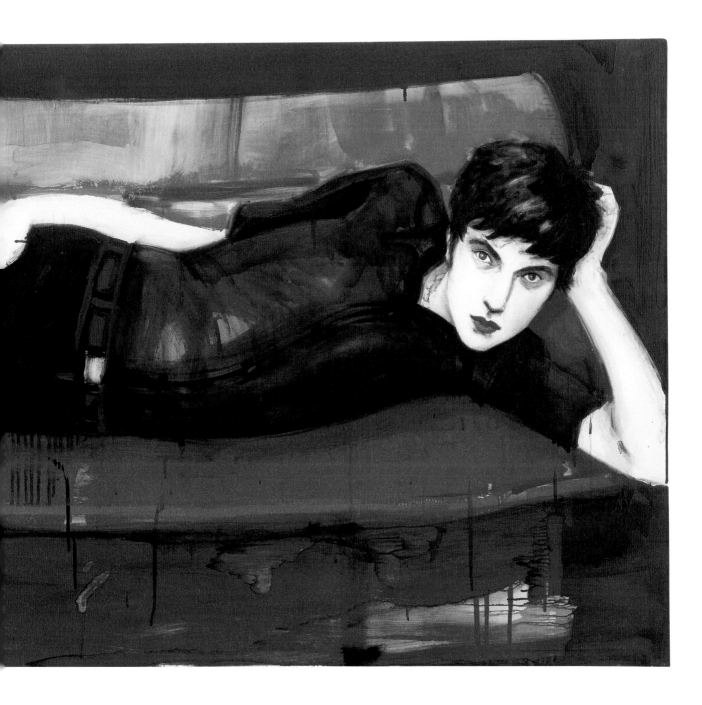

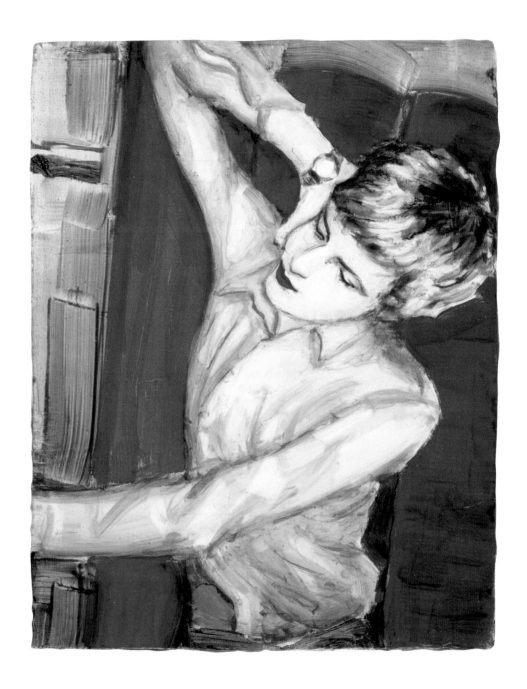

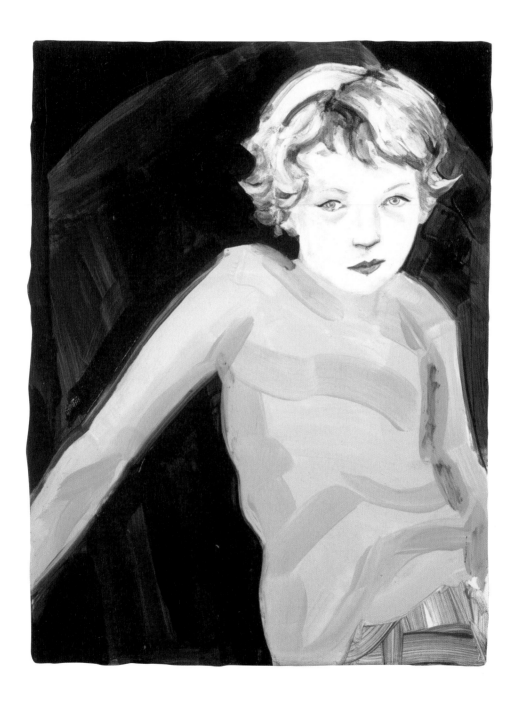

»Max«, 1996, oil on board, 30,5 x 22,9 cm Collection Gavin Brown

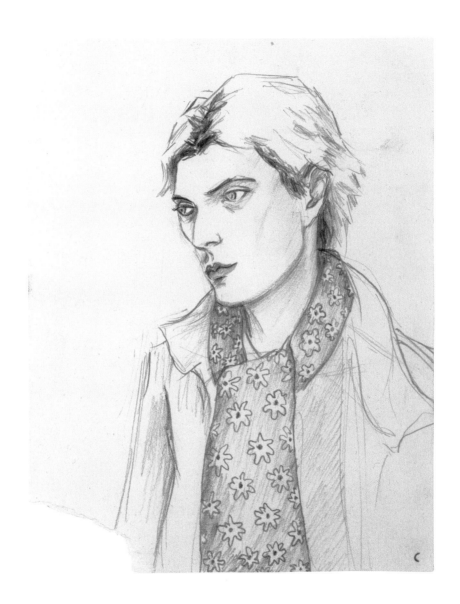

»Craig«, 1996, pencil on paper, 20,3 x 17,8 cm Collection Tony Just & Elizabeth Peyton

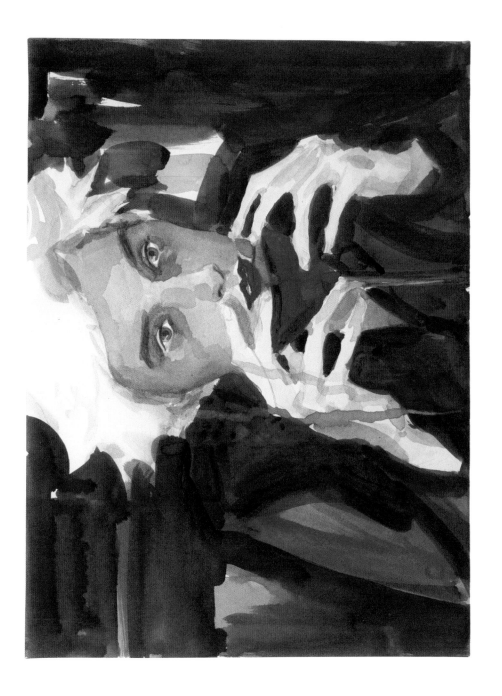

»Craig«, 1996, watercolour on paper, 22,9 x 30,5 cm Collection Nina & Frank Moore

49

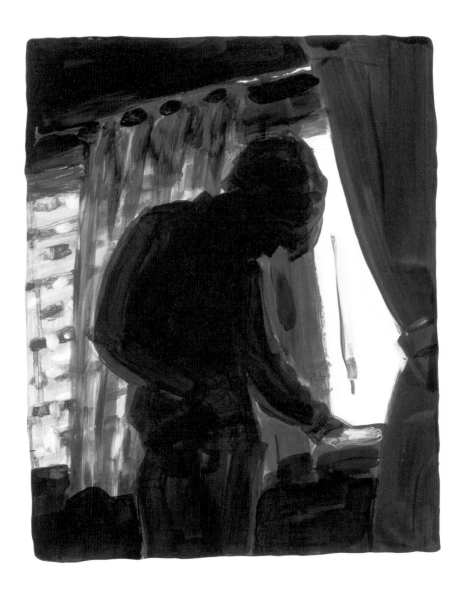

»Tokyo (Craig)«, 1997, oil on board, 25,4 x 20,3 cm Ole Faarup Collection, Copenhagen

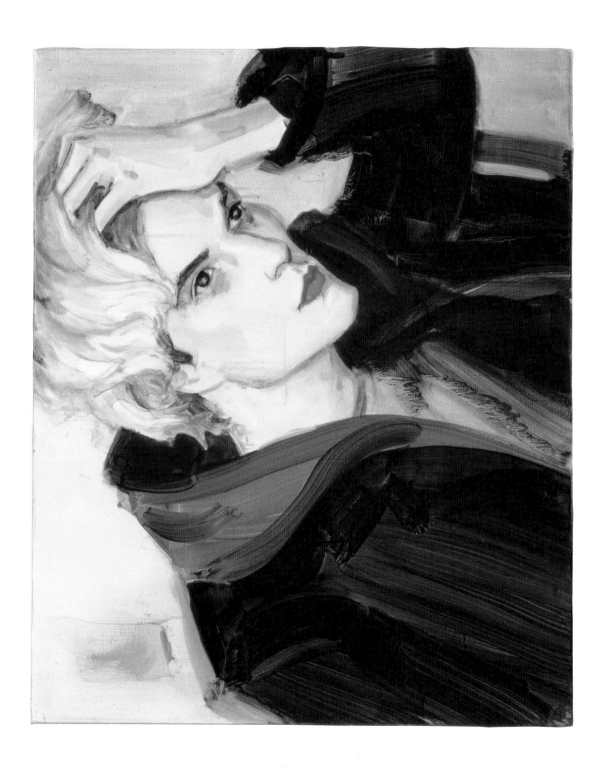

»Craig«, 1997, oil on canvas, 35,6 x 43,2 cm Collection David Teiger

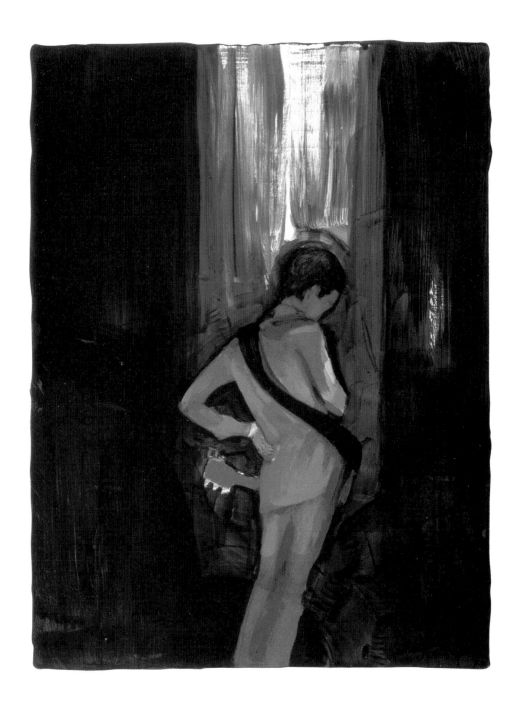

»Roseland«, 1997, oil on board, 30,5 x 22,9 cm Emanuel Hoffmann-Stiftung, Depositum im Museum für Gegenwartskunst, Basel

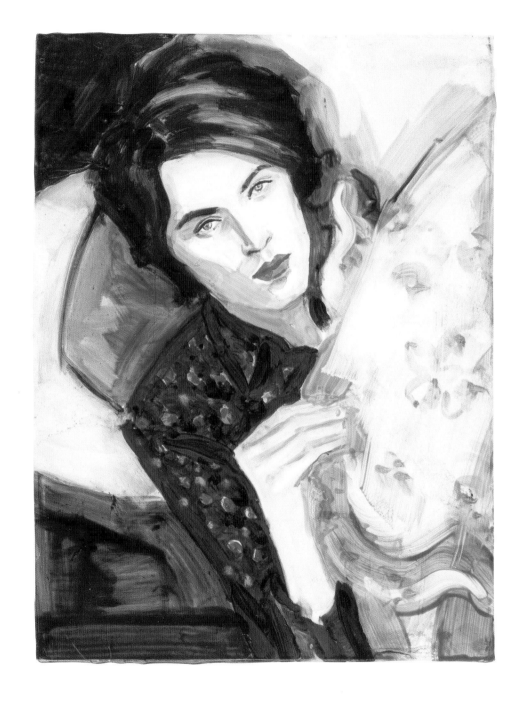

»Evan with the flu«, 1997, oil on board, 22,9 x 30,5 cm Private Collection

55

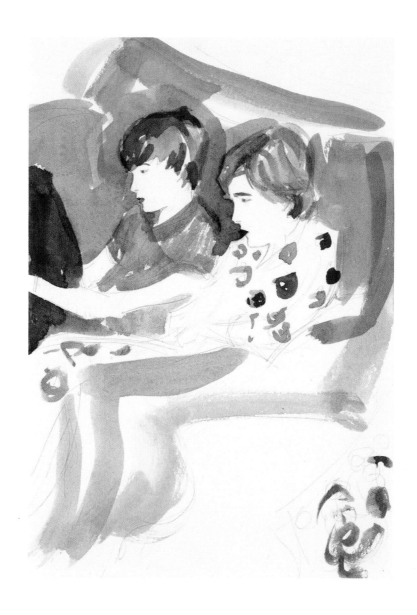

»Charles & Diana Spencer«, 1997, watercolor on paper, 17,8 x 25,4 cm Private Collection

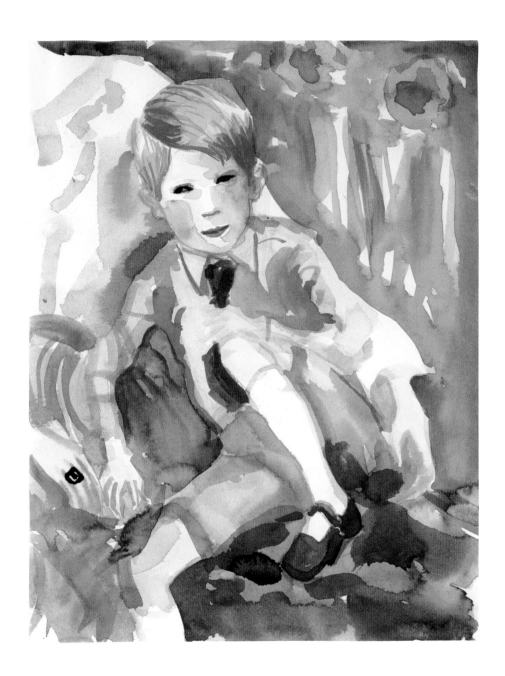

»Prince Harry«, 1997, watercolour on paper, 27,9 x 21,6 cm Collection Linda Farris & John Kucher, Seattle

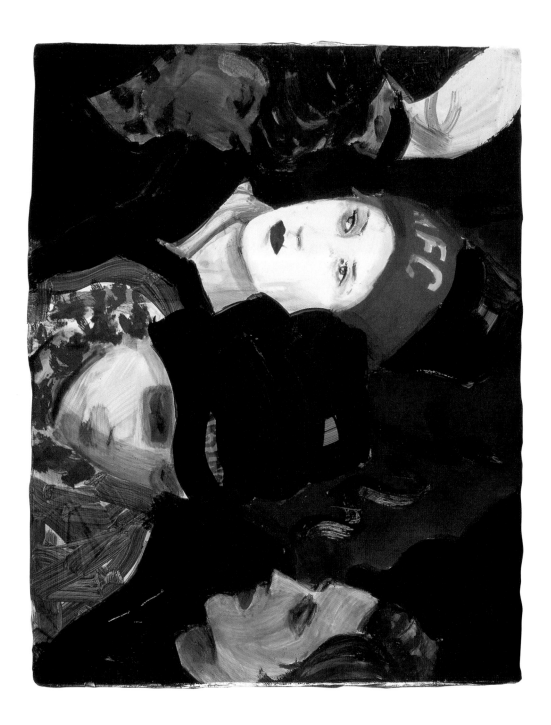

»Arsenal (Prince Harry)«, 1997, oil on board, 27,9 x 35,6 cm Private Collection, London, Courtesy Sadie Coles HQ, London

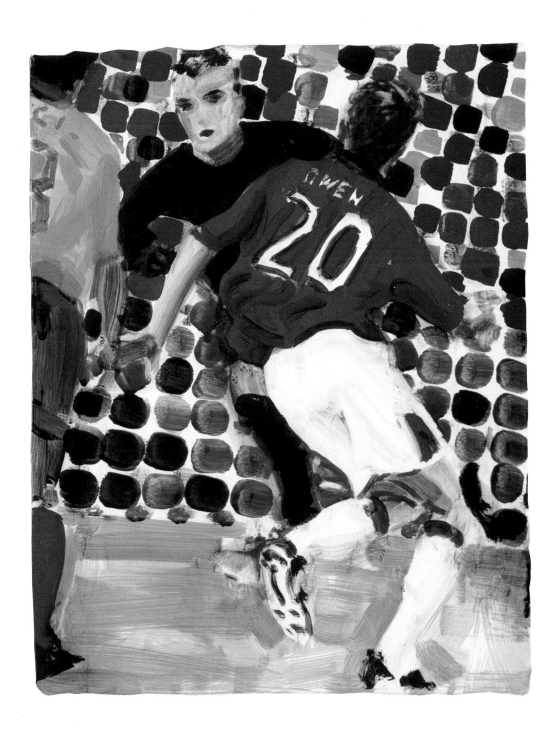

61

»Michael Owen«, 1998, oil on board, 35,6 x 27,9 cm Emanuel Hoffmann-Stiftung, Depositum im Museum für Gegenwartskunst, Basel

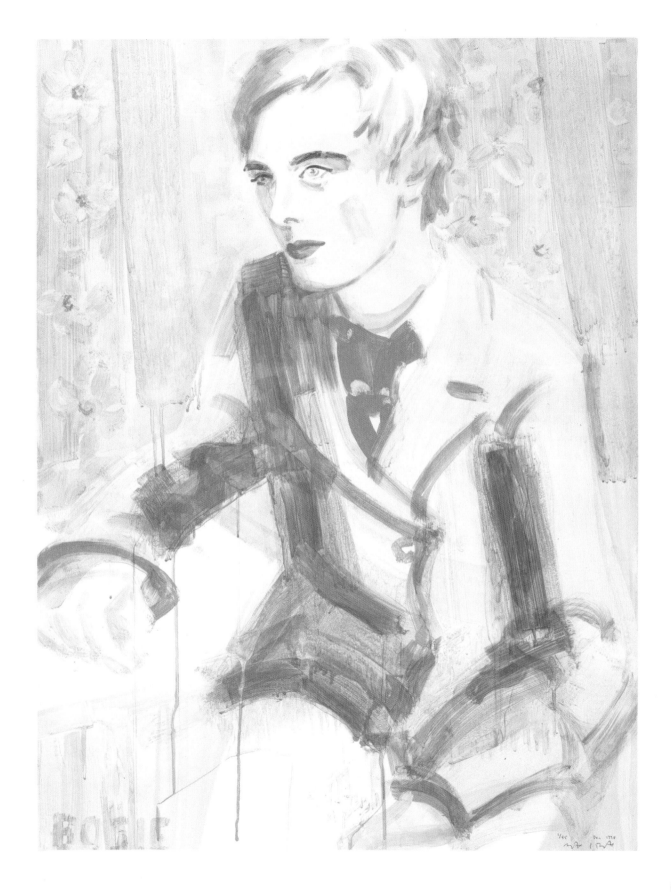

»Bosie«, 1998, lithograph, 49,5 x 57,2 cm Emanuel Hoffmann-Stiftung, Depositum im Museum für Gegenwartskunst, Basel

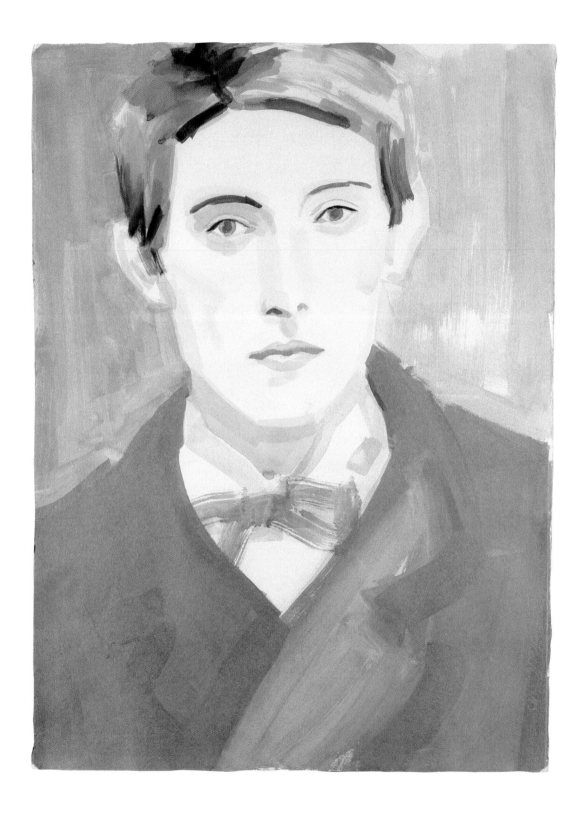

»Silver Bosie«, 1998, watercolor on paper, 76,2 x 56,5 cm Renato Alpegiani Collection

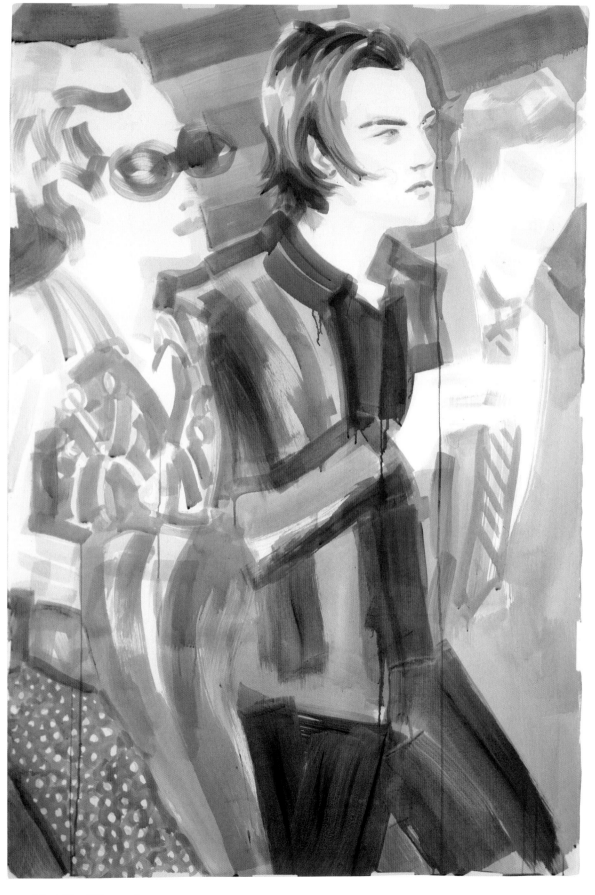

»Atlantic City«, 1998, watercolor on paper, 151,4 x 102,9 cm Mima & César Reyes, San Juan, Puerto Rico

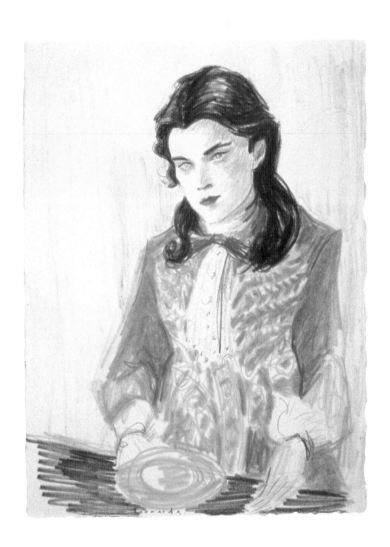

»Leonardo di Caprio as Louis XIV«, 1998, color pencil on paper, 19,1 x 14,6 cm Arthur & Jeanne Cohen, Los Angeles

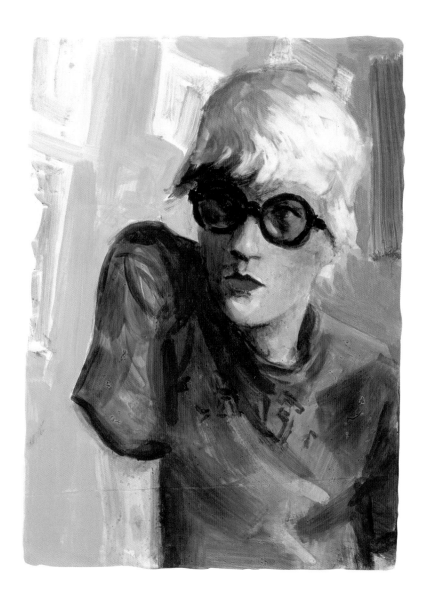

»David Hockney (Powis Terrace bedroom)«, 1998, oil on board, 24,8 x 17,8 cm Kunstmuseum Wolfsburg

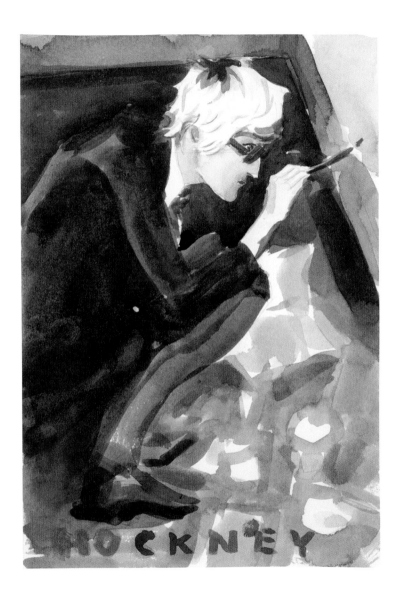

»David Hockney«, 1997, watercolor on paper, 26,7 x 17,8 cm Collection Nancy & Joel Portnoy

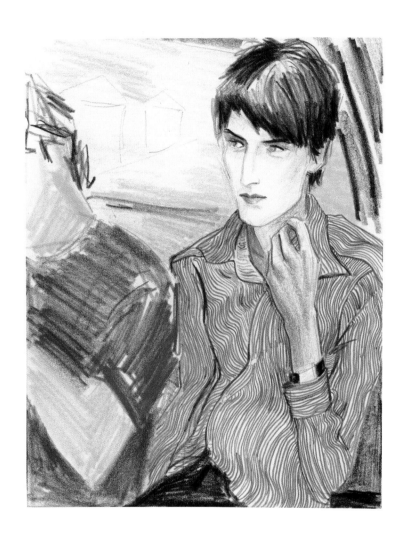

»Stephen Malkmus«, 1998, color pencil on paper, 19,7 x 15,2 cm Collection Gastona Ranzato

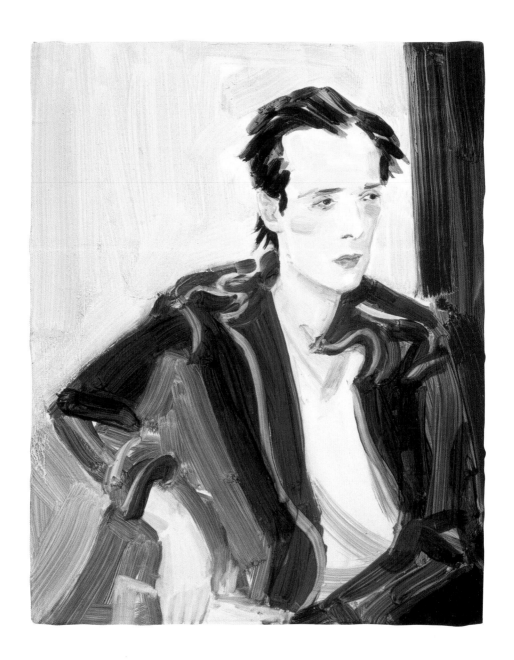

»Silver Colin«, 1998, oil on board, 26 x 21 cm Mimi & Peter Haas

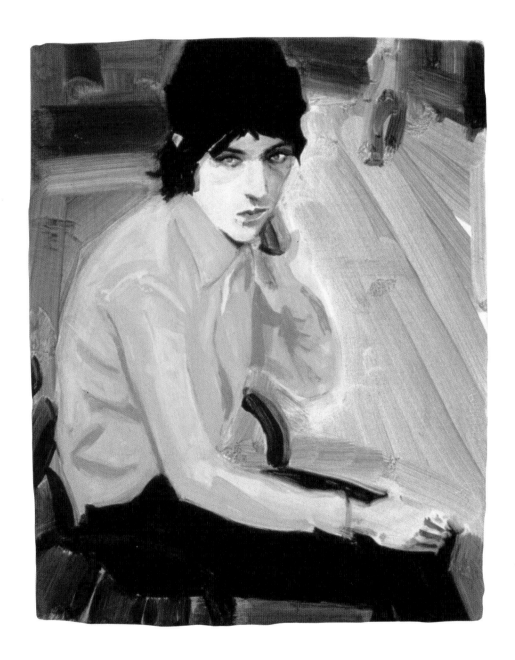

»Elliot in the park«, 1999, oil on board, 27,9 x 20,3 cm Emanuel Hoffmann-Stiftung, Depositum im Museum für Gegenwartskunst, Basel

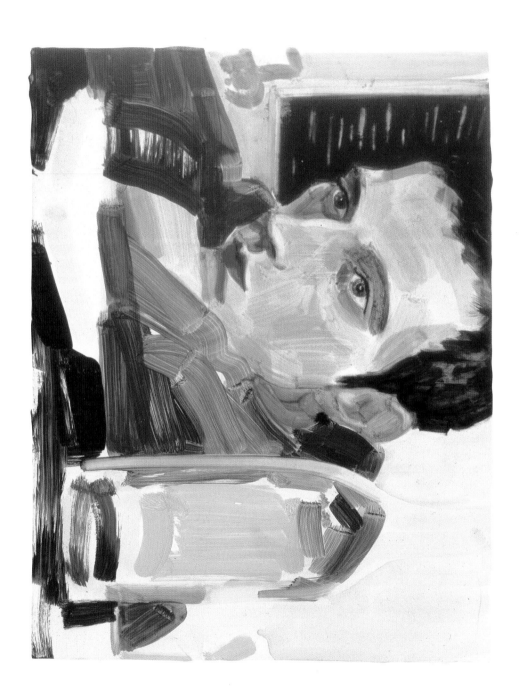

»Martin Creed«, 1999, oil on board, 27,9 x 35,6 cm Private Collection

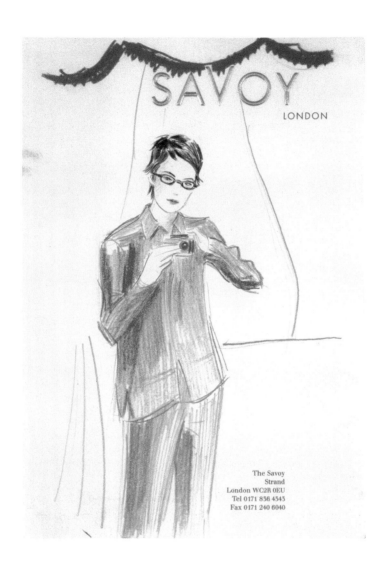

The Savoy
Strand
London WC2R 0EU
Tel 0171 836 4343
Fax 0171 240 6040

»Savoy (Self-Portrait)«, 1999, color pencil on paper, 21 x 14,6 cm Private Collection, Berlin, Courtesy Neugerriemschneider, Berlin

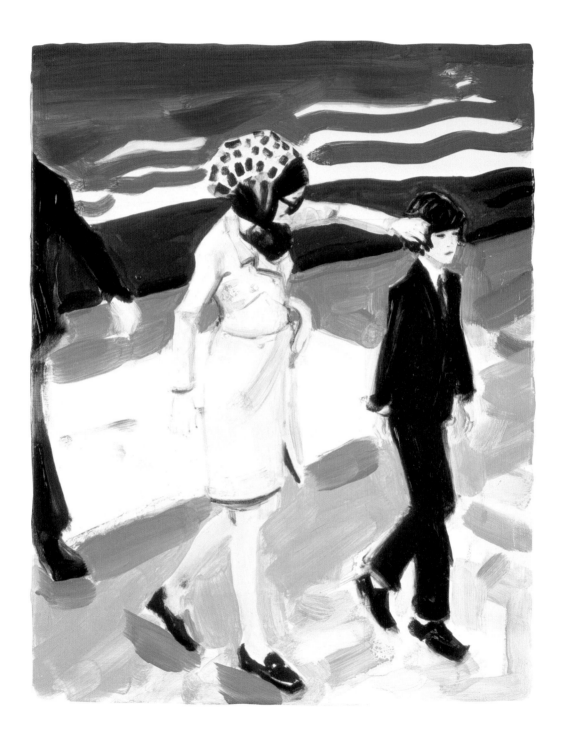

»Jackie & John (Jackie fixing John's Hair)«, 1999, oil on board, 35,6 x 27,6 cm Collection Mr. & Mrs. Jeffrey R. Winter

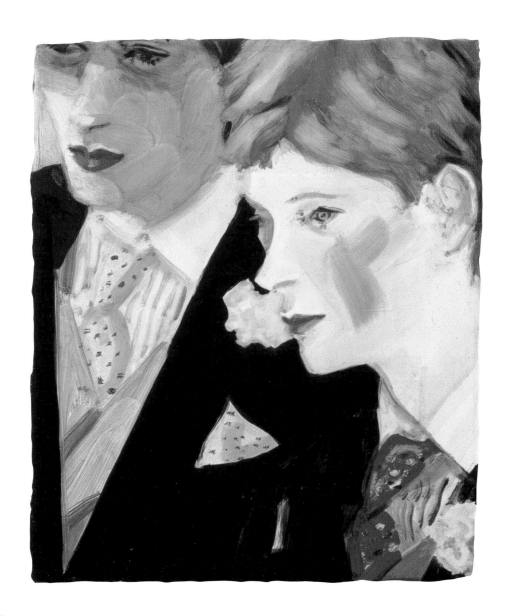

»Prince Harry & Prince William«, 1999, oil on board, 24,1 x 20,3 cm Musée national d'art moderne, Centre Georges Pompidou, Paris

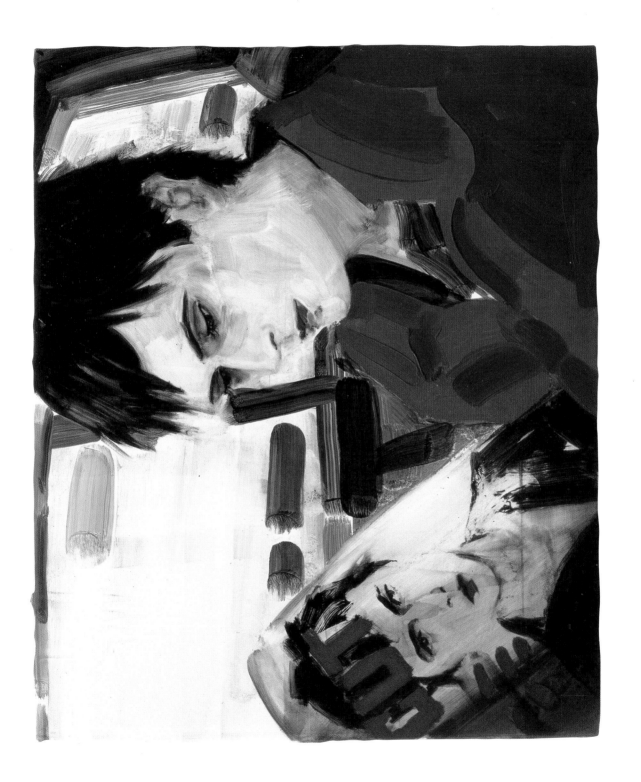

»Brett and Rob«, 1999, oil on board, 35,6 x 42,5 cm Private Collection

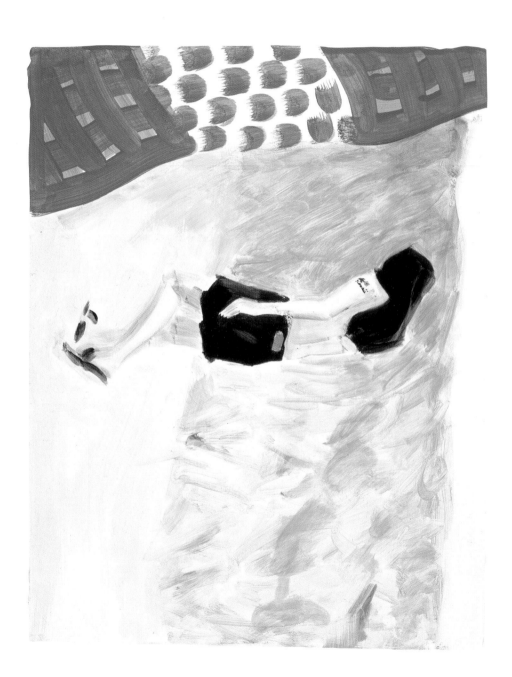

»Hawaii (Rob in Long Island)«, 1999, oil on board, 27,9 x 35,6 cm Laura Steinberg & Bernardo Nadel Ginard

»Daniel in Bed, June 1999«, 1999, oil on board, 34,6 x 43,2 cm Wolfgang Tillmans

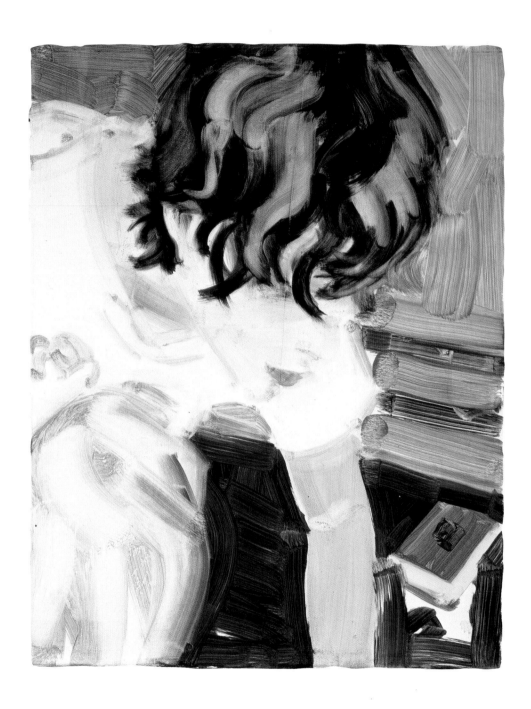

»Silver Tony«, 1999, oil on board, 35,6 x 27,9 cm Collection Byron R. Meyer, San Francisco

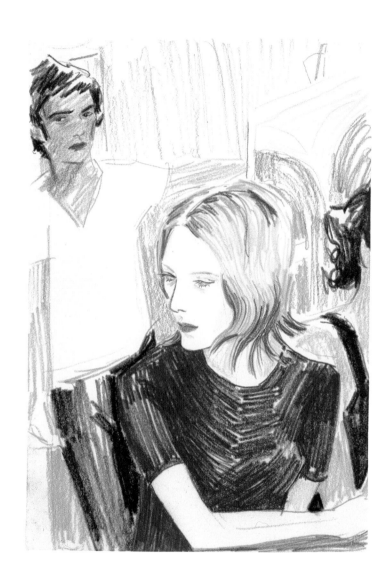

»Gavin and Kirsty«, 1999, color pencil on paper, 22,2 x 15,2 cm Collection Gavin Brown

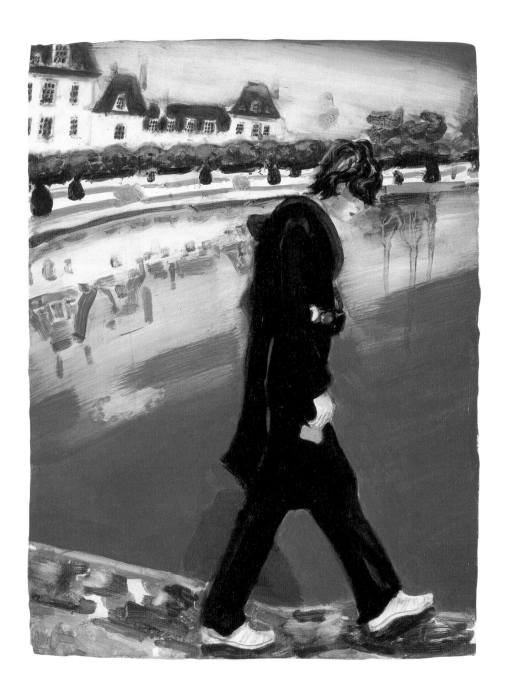

»Prince Eagle (Fontainebleau)«, 1999, oil on board, 30,5 x 22,9 cm Collection of the artist

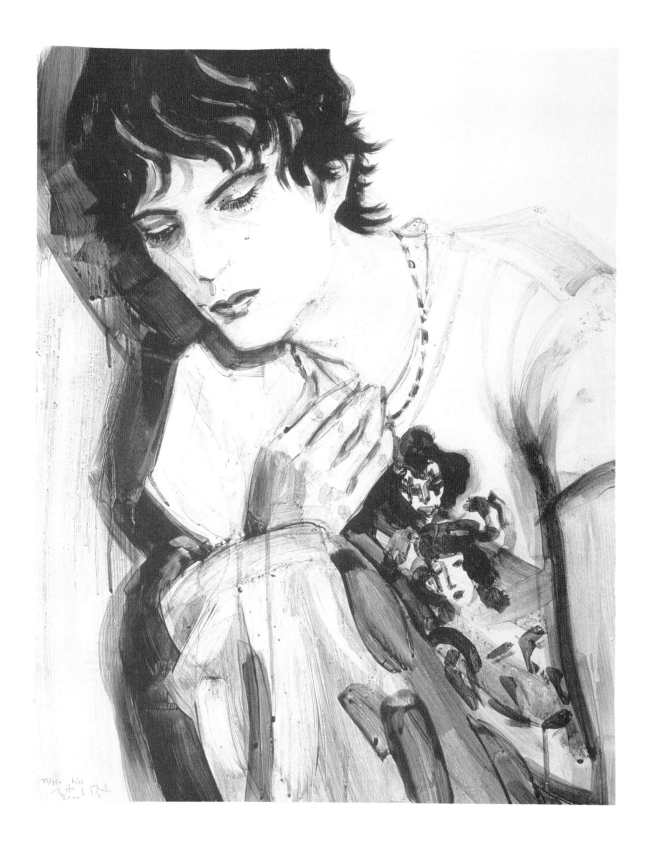

»Kiss(Tony)«, 2000, lithograph, 61 x 48,3 cm Private Collection, Courtesy Neugerriemschneider, Berlin

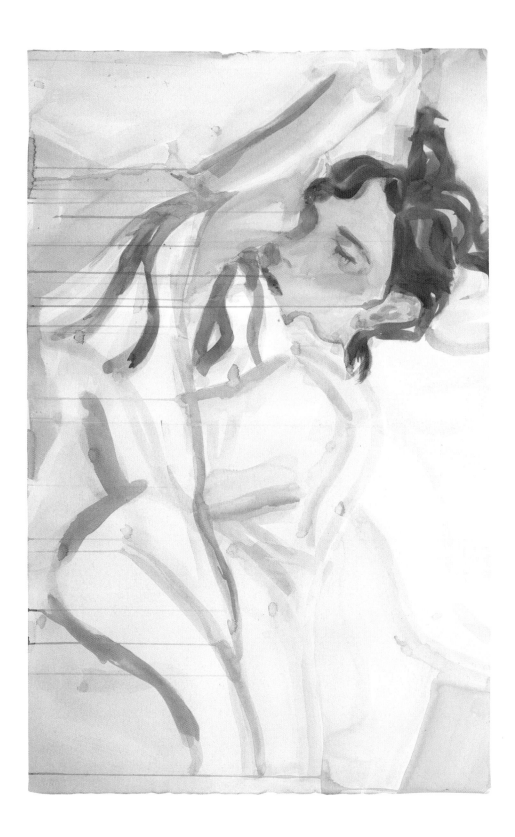

»Pierre, (Tony)«, 2000, watercolor on paper, 40,6 x 50,8 cm Lorenzo Sassoli di Bianci Collection, Bologna, Courtesy Sadie Coles HQ, London

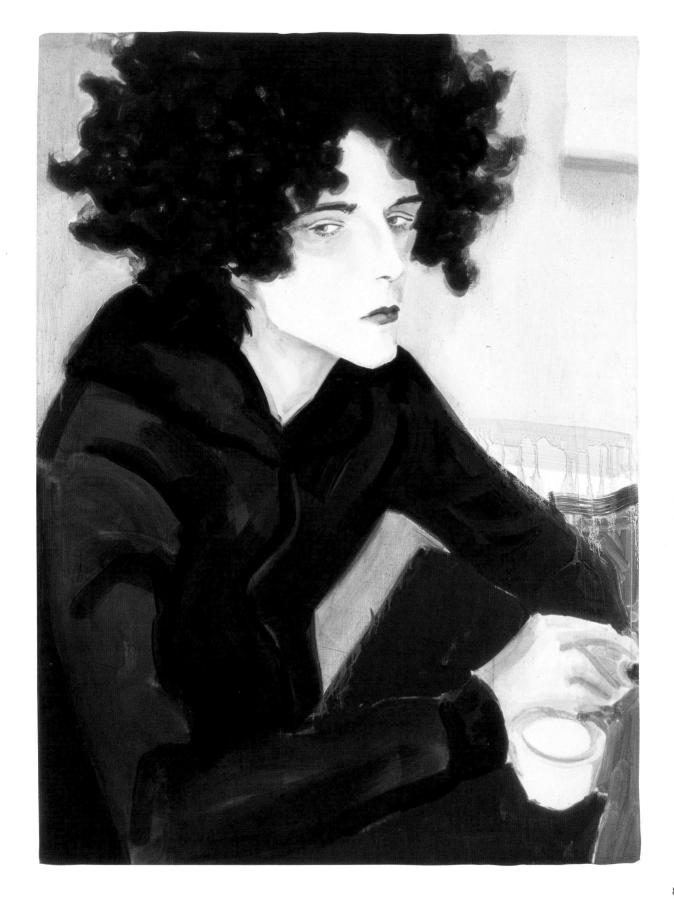

»Berlin (Tony)«, 2000, oil on canvas, 101,6 x 76,2 cm Sammlung Hauser & Wirth, St. Gallen

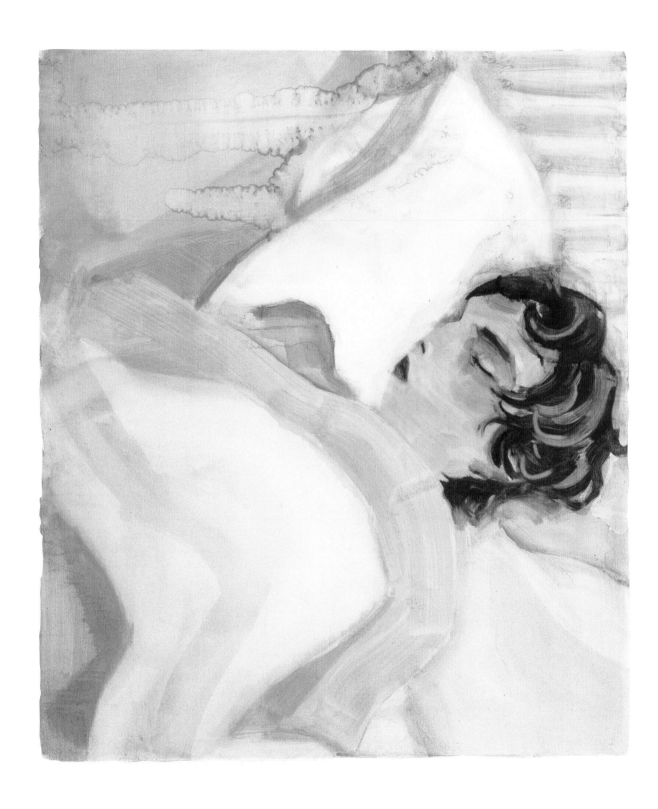

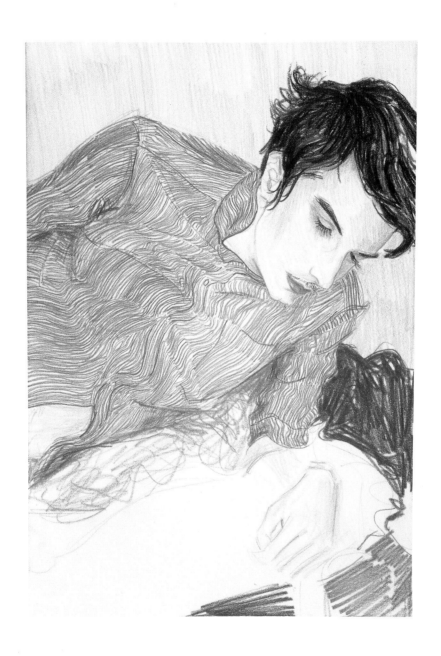

»Spencer«, 1999, color pencil on paper, 22,2 x 15,2 cm
Collection of the Museum of Modern Art, New York, fractional and promised gift of David Teiger

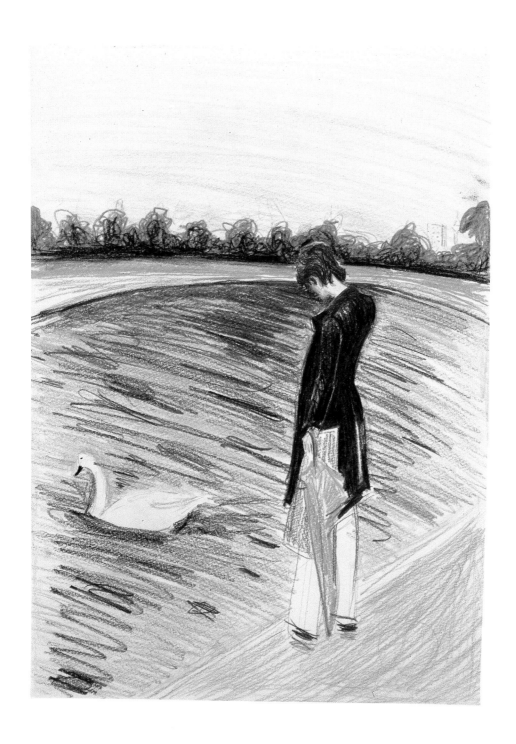

»Swan (Tony, Hyde Park)«, 2000, color pencil on paper, 33 x 24,1 cm Private Collection

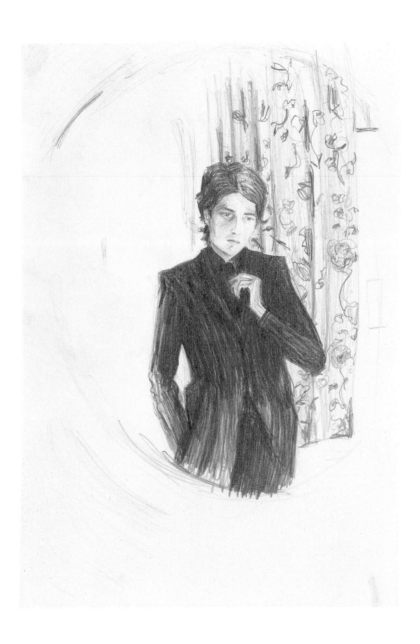

»Leonard Cohen«, 2000, pencil on paper, 21,6 x 15,2 cm Private Collection, Berlin, Courtesy Neugerriemschneider, Berlin

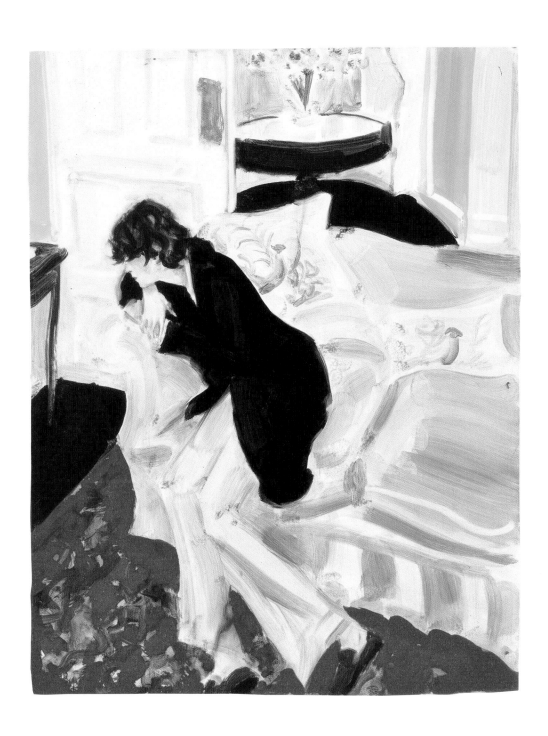

»Torosay (Tony)«, 2000, pencil on paper, 22,9 x 30,5 cm Kunstmuseum Wolfsburg

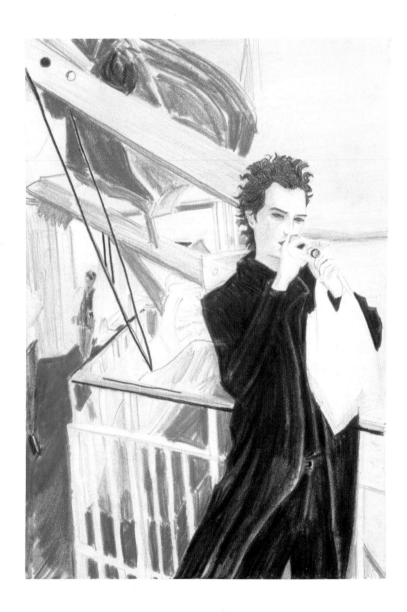

»Tony (boat from Oban)«, 2001, color pencil on paper, 21,6 x 15,2 cm Collection Patricia & Morris Orden, New York

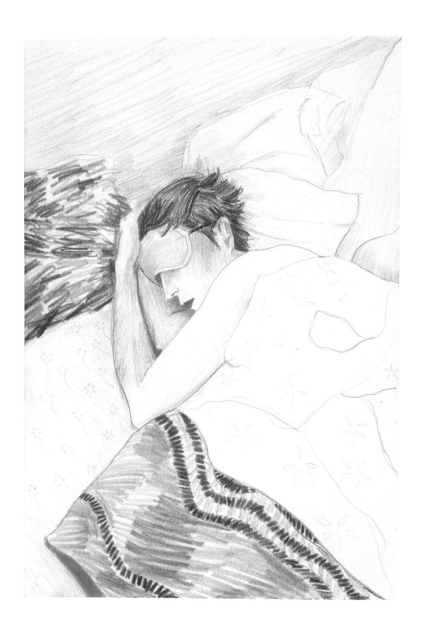

»Tony Sleeping with Furbie«, 2001, color pencil on paper, 21,6 x 15,2 cm Collection Nancy & Joel Portnoy

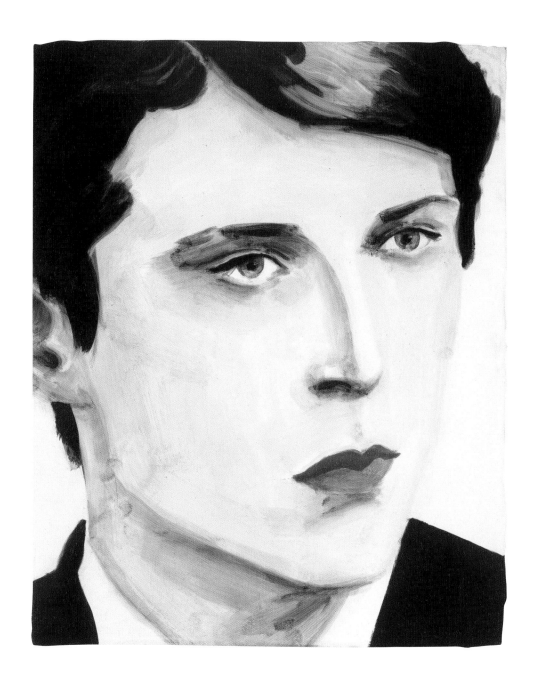

»Democrats are more beautiful«, 2001, oil on board, 25,4 x 20,3 cm Laura Steinberg Tisch & Stafford Broumand

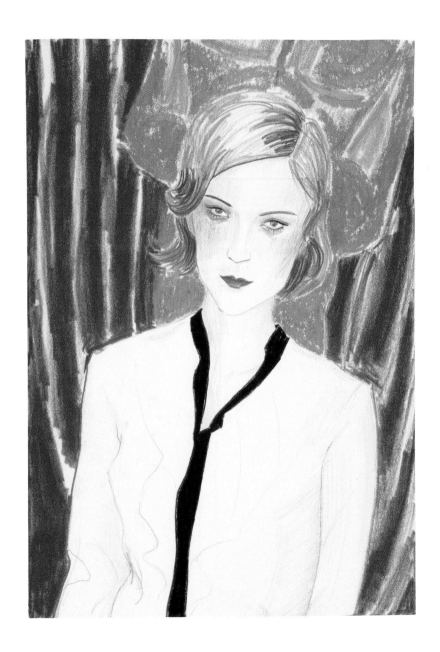

»Chloe«, 2001, color pencil on paper, 21,9 x 15,2 cm Collection Martin & Rebecca Eisenberg, New York

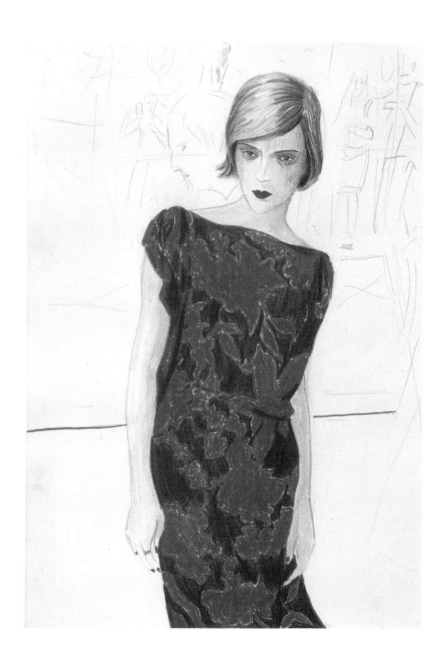

»Chloe«, 2000, color pencil on paper, 22,2 x 15,2 cm Collection Martin & Rebecca Eisenberg, New York

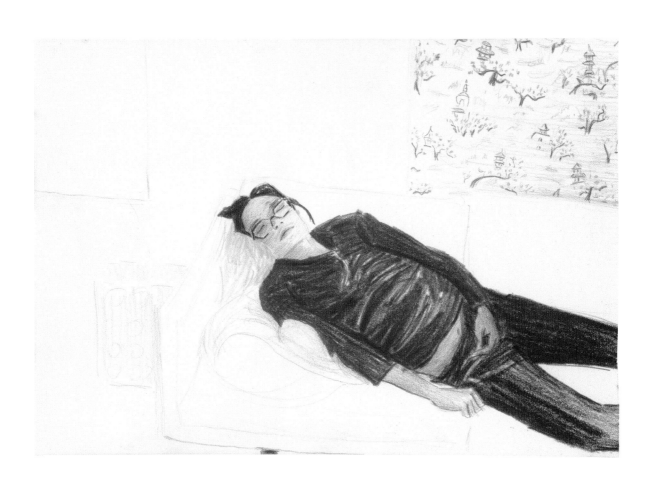

»Pou (Rirkrit)«, 2001, color pencil on paper, 15,1 x 21,9 cm Courtesy Gavin Brown's enterprise, New York

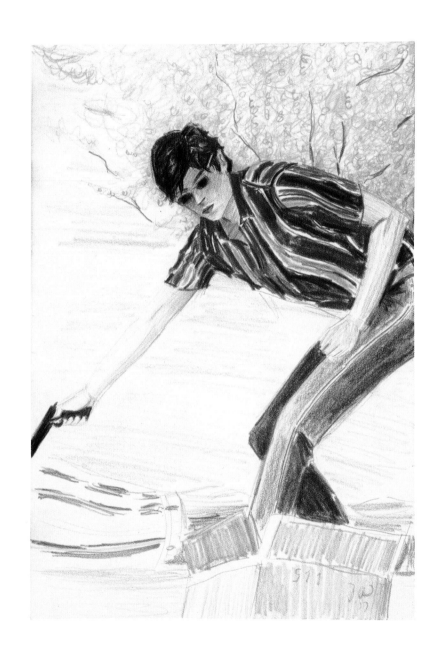

»Benecio«, 2001, color pencil on paper, 21,9 x 15,1 cm Courtesy Gavin Brown's enterprise, New York

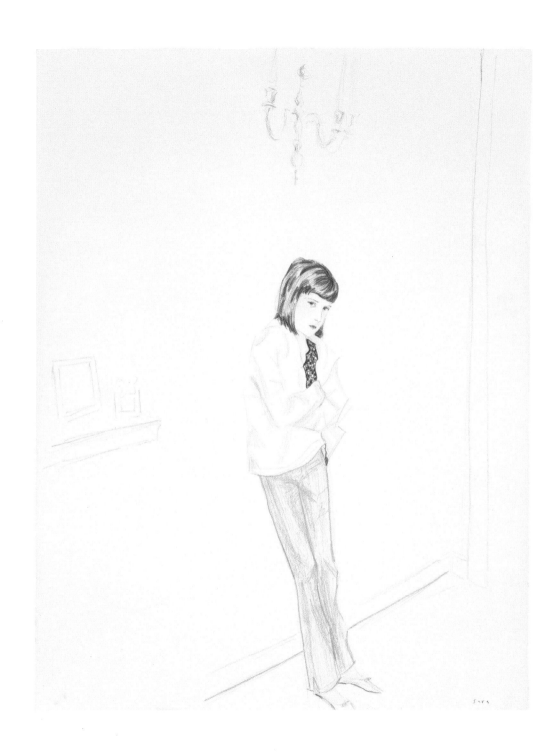

»Sara on her Birthday«, 2001, color pencil on paper, 29,5 x 22,7 cm Collection Mandy & Cliff Einstein, Los Angeles

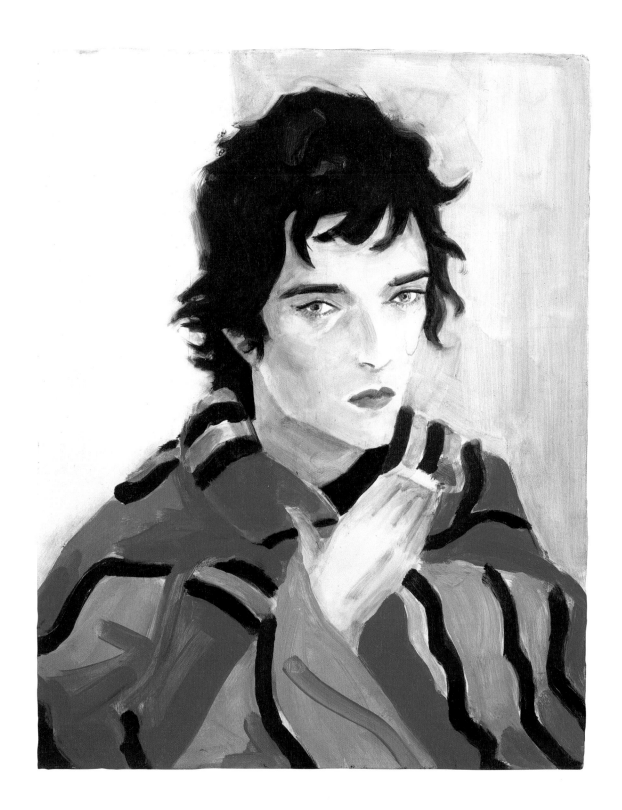

»Luing (Tony)«, 2001, oil on board, 35,6 x 27,9 cm Private Collection, New York

Elizabeth Peyton

born 1965 in Danbury, Connecticut
lives and works in New York

Education
School of Visual Arts, New York, BFA 1984–87

Solo Exhibitions
(C) = Catalogue Publication

1987	Althea Viafore, New York
1992	Water Closet, Novocento, New York
1993	Gavin Brown's enterprise at Hotel Chelsea, Room 828, New York
1995	Cabinet Gallery at The Prince Albert, London
	Burkhard Riemschneider, Köln
	Gavin Brown's enterprise, New York
1996	Gavin Brown's enterprise, New York
	Galleria Il Capricorno, Venice
	Neugerriemschneider, Berlin
1997	Gallery Side 2, Tokyo
	Galerie Daniel Buchholz, Cologne
	Saint Louis Art Museum, Saint Louis (C)
	Gavin Brown's enterprise, New York
	Regen Projects, Los Angeles
1998	Georg Kargl, Vienna
	Galleria Il Capricorno, Venice
	Museum fur Gegenwartskunst, Basel; Kunstmuseum Wolfsburg (C)
	Seattle Art Museum, Seattle
	Sadie Coles HQ, London
1999	Regen Projects, Los Angeles
	Museum of Contemporary Art, Castello di Rivoli, Turin
	Neugerriemschneider, Berlin
	Gavin Brown's enterprise, New York
2000	Westfälischer Kunstverein, Münster (C)
	Aspen Art Museum, Aspen (C)
	Sadie Coles HQ, London
	Gavin Brown's enterprise, New York
2001	Deichtorhallen Hamburg (C)
	Gavin Brown's enterprise, New York

Group Exhibitions (selected)

1993 »Okay Behaviour«, 303 Gallery, New York

1995 »Campo«, Venice Biennale (C)

1996 »Ein Stück vom Himmel«, Kunsthalle Nürnberg; South London Gallery
 »Universalis«, Sao Paulo Bienal, Sao Paulo (C)
 »Wunderbar«, Kunstverein, Hamburg; Kunstraum, Vienna (C)

1997 »Truce: Echoes of Art in an Age of Endless Conclusions«, Site Santa Fe (C)
 Center for Curatorial Studies, Annandale-on-Hudson (C)
 »New Work: Drawings Today«, San Francisco MOMA, San Francisco
 »Heaven«, P. S. 1, New York (C)
 »Longing and Memory«, Los Angeles County Museum, Los Angeles
 »Projects 60«, The Museum of Modern Art, New York

1998 »Young Americans II«, Saatchi Gallery, London (C)
 »Tell me a Story«, Centre National d'Art Contemporain de Grenoble, Grenoble (C)
 Magasin, Centre National d'Art Contemporain de Grenoble, Grenoble (C)
 »Auf der Spur«, Kunsthalle Zürich

1999 »Gesammelte Werke 1, Zeitgenössische Kunst seit 1968«, Kunstmuseum Wolfsburg
 »Examining Pictures«, Whitechapel Art Gallery, London;
 Museum of Contemporary Art, Chicago;
 UCLA at the A. Hammer Museum, Los Angeles (C)

2000 »Greater New York«, P. S. 1, New York (C)
 »Interventions«, Milwaukee Art Museum, Milwaukee (C)
 »American Academy Invitational Exhibition of Painting and Sculpture«,
 American Academy of Arts and Letters, New York

2001 »Beautiful Productions: Art to Play, Art to Wear, Art to Own«,
 Whitechapel Art Gallery, London
 »Longing and Memory«, Los Angeles County Museum of Art, Los Angeles
 »Collaborations with Parkett: 1984 to Now«, The Museum of Modern Art, New York (C)
 »About Face; Selections from the prints and illustrated books department«,
 The Museum of Modern Art, New York
 »Azerty«, Musée national d'art moderne, Centre Georges Pompidou, Paris

Bibliography (selected)

1993 Blau, Douglas/*Hotel Chelsea*, New York (C)

 Hoptman, Laura/*Balkon*, September

1994 Ettal, Meicost/Ouverture, *Flash Art*, November, p. 88

 Saltz, Jerry/Review, *Art in America*, May, p. 122

1995 Bonami, Francesco/Interview, *Flash Art*, March/April, pp. 84–86

 Smith, Roberta/»Blood and Punk Royalty to Grunge Royalty«,
 The New York Times/March 24, p. C 32

1996 Decter, Joshua/*a/drift*, p. 17

 Savage, Jon/»Boys Keep Swinging«, *Frieze*, November/December, pp. 58–61

 Universalis/Sao Paulo Bienal, Sao Paulo, Brasil (C)

1997 Dobrzynski, Judith/»A Popular Couple Charge into the Future of Art,
 but in Opposite Directions«/*The New York Times*, September 2, p. C 11/C 13

 Peyton, Elizabeth/»Live Forever«, Composit Press & Synergy, Japan (C)

 Saltz, Jerry/Review, *Time Out New York*, March 27–April 3, p. 43

 Schjeldahl, Peter/»Peyton's Place«, *The Village Voice*, March 25

 Schjeldahl, Peter/»The Daub Also Rises«, *The Village Voice*, July 29, p. 85

 Smith, Roberta/»Projects«, *New York Times*, August 1

 Steiner, Rochelle/»currents 71«, The Saint Louis Art Museum (C)

1998 Fairbrother, Trevor/»Prime of Life«, Seattle Art Museum (C)

 Hickey, Dave/Elizabeth Peyton, Museum für Gegenwartskunst, Basel;
 Kunstmuseum Wolfsburg (C)

 Liebmann, Lisa/»A Tender Trap«, *Parkett # 53*, pp. 85–91

 Peyton, Elizabeth/Craig, Cologne,
 Edition Salzau & Verlag der Buchhandlung Walter König (C)

 Pilgrim, Linda/»An Interview with a Painter«, *Parkett # 53*, pp. 59–65

 Rimenelli, David/»Unhappy Kings«, *Parkett # 53*, pp. 66–71

 Stange, Raimar/*Artist Kunstmagazin # 37*, pp. 46–50

 Ursprung, Philip/»In Praise of Hands: Elizabeth Peyton's Painting«, *Parkett # 53*, pp. 80–93

 Wakefield, Neville/»Elizabeth Peyton«, *Elle Decor*, March, p. 72

1999 Pagel, David/Elizabeth Peyton, *Los Angeles Times*, November 5, p. F 26

 Philippi, Anne/Elizabeth Peyton, *Park & Ride*, July/August, pp. 8–9

 Saltz, Jerry/»Getting Real«, *The Village Voice*, April 20

2000 »Elizabeth Peyton«/*Brutus*, Tokyo, April

 »Elizabeth Peyton«/*Inter Vista*, Vol. IV, Summer

 Harvey, Doug/»Elizabeth Peyton«, *Art Issues*, January/February, p. 51

 Lafreniere, Steve and Pruitt, Rob/»Elizabeth Peyton«, *Index*, July, pp. 54–61

2001 Miles, Christopher/Review, *Artforum*, January

Acknowledgements:

Thank you and gratitude to everyone who made this catalogue and show at the Deichtorhallen happen. Especially to Zdenek Felix, Annette Sievert, everyone at the Deichtorhallen and Ronald Jones. And to: Tony Just, Gavin Brown, Kirsty Bell, Corinna Durland, Ben Brunnemer, Anton Hottner, Frederique Baumgartner, Laura Mitterand, Burkhard Riemschneider, Tim Neuger, Susanne Küper, Solome Sommer, Sadie Coles, Pauline Daley, Sean Caley Regen, Lisa Overduin, Daniel Buchholz, Christopher Müller, Bruna Aickelin and my family.

Elizabeth Peyton

Publikation zur Ausstellung/Publication on the occasion of the exhibition
»Elizabeth Peyton«, Deichtorhallen Hamburg, 28. September 2001–13. Januar 2002

Ausstellungsleitung/Curator of the exhibition: Zdenek Felix
Ausstellungsassistenz/Curatorial assistant: Annette Sievert, Angelika Leu-Barthel
Redaktion des Kataloges/Catalogue editing: Zdenek Felix, Annette Sievert
Lektorat/Copy editing: Birgit Hübner, Jackie Todd
Übersetzung/Translations: Belinda Grace Gardner
Fotos: Courtesy the artist and Metro Pictures (Cindy Sherman, »Untitled Filmstill #49«, p. 14)
Courtesy Barbara Gladstone (Richard Prince, »Untitled (hand with cigarette)«, p. 17)
Courtesy the artist and Galerie Johnen und Schöttle (Richard Phillips, »Scout«, p. 18)
Courtesy Sadie Coles HQ, London (»Napoleon«, p. 25)
Jens Rathmann (»Crown Prince Ludwig«, p. 27)
Paul Louis, Bruxelles (»Franz in front of the Deichtorhallen«, p. 35)
Kunstmuseum Wolfsburg (»David Hockney«, p. 68)
Cnac – Mnam/Dist RMN (»Prince Harry & Prince William«, p. 74)
Öffentliche Kunstsammlung Basel (»Savoy [Tony]«, p. 98)
Alle weiteren Abbildungen/Any further reproductions of Elizabeth Peyton:
Courtesy Gavin Brown's enterprise, New York
Umschlagabbildung/Cover illustration:
Vorne/Front: »Spencer drawing«, 2000, oil on board, Collection Gavin Brown
Hinten/Back: »Savoy (Self-Portrait)«, 1999, color pencil on paper, Private Collection, Berlin,
Courtesy Galerie Neugerriemschneider, Berlin
Gestaltung: Panhans\Grau
Gesamtherstellung/Printed by: Dr. Cantz'sche Druckerei, Ostfildern

**2nd edition © 2002 Deichtorhallen Hamburg, Hatje Cantz Verlag, Ostfildern-Ruit,
und Autoren/and authors**

Erschienen im/Published by Hatje Cantz Verlag
Senefelderstraße 12, 73760 Ostfildern-Ruit, Germany
Tel. + 49-711-440 50
Fax + 49-711-440 52 20
Internet: www.hatjecantz.de

DISTRIBUTION IN THE US, D.A.P., Distributed Art Publishers, Inc.
155 Avenue of the Americas, Second Floor, New York, N.Y. 10013-1507, USA
Tel. + 1-212-627 19 99
Fax + 1-212-627 94 84

ISBN 3-7757-9099-3

Printed in Germany

Supported by **BRITISH AMERICAN TOBACCO** GERMANY